IMAGES
of America

WAKEFIELD
REVISITED

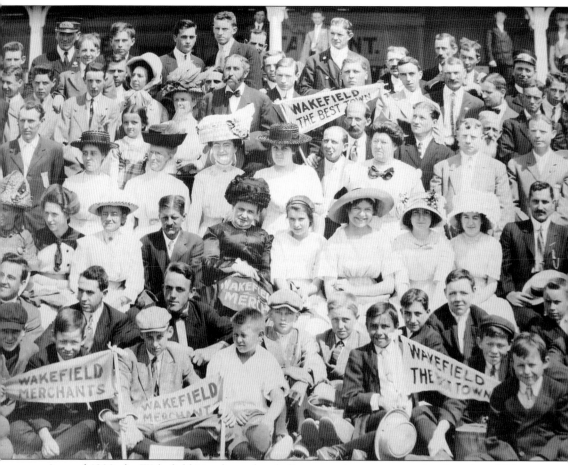

Around 1900, the Wakefield Merchants baseball team and supporters took a day trip to Nahant. Several trolleys were hired to transport the crowd, which assembled for this photograph taken before the game. The spirit of the community is evidenced in the pennants declaring Wakefield as "The Best Town." (Courtesy of the Wakefield Historical Society.)

ON THE COVER: On June 17, 1902, the Soldiers and Sailors Monument on the Upper Common was dedicated in a grand ceremony attended by Gov. Winthrop Crane and many other officials. Five hundred public school children sang patriotic songs for the occasion. Funds for the monument's construction were donated to the town by Harriet Flint in honor of her husband, Charles. Harriet Flint's will specified that the monument be "symmetrical in architecture, beautiful in design and finish, attended with solid, thorough workmanship—a monument worthy of the men to whom we dedicate it." It was fabricated by the Van Amringe Granite Company of Boston, which had created 87 memorials at Gettysburg alone, along with other work at Antietam, Chickamauga, and Chattanooga battlefields. The sculpture is thought to be the work of Melzar Hunt Mossman (1846–1926), a Civil War veteran himself. (Courtesy of the Wakefield Historical Society.)

IMAGES
of America

WAKEFIELD
REVISITED

Nancy Bertrand

ARCADIA
PUBLISHING

Published by Arcadia Publishing
Charleston, South Carolina

Printed in the United States of America

Library of Congress Control Number: 2010927290

For all general information, please contact Arcadia Publishing:
Telephone 843-853-2070
Fax 843-853-0044
E-mail sales@arcadiapublishing.com
For customer service and orders:
Toll-Free 1-888-313-2665

Visit us on the Internet at www.arcadiapublishing.com

CONTENTS

ACKNOWLEDGMENTS

The Wakefield Historical Society, founded in 1890, works to gather and preserve the artifacts, images, and information that chronicle the history of our town. All of the images in this volume, unless otherwise noted, have come from the Wakefield Historical Society's collection.

The dedicated work of this organization, and that of many individuals concerned with Wakefield's "past keeping," must be acknowledged. It would be impossible to name all who have contributed to the town's accumulated records and research, from the first great historian, Lilley Eaton, through the artists Franklin Poole and Joseph Payro, historian William E. Eaton, and the late great generation of historical society members—Ruth Woodbury, Bill Jones, and Clarence Purrington. Much has been learned through the oral history interviews conducted by the Wakefield Historical Commission. I have also learned much from the late historian of the Wakefield Fire Department, L. Murray Young.

In writing this volume, I have repeatedly referred to Lilley Eaton's 1872 *Genealogical History of Wakefield, Reading and North Reading*, and to the anniversary volumes published in 1894 and 1944. I was fortunate enough to have participated in the writing of the town's comprehensive 350th anniversary history, *Wakefield: 350 Years by the Lake*, and gathered much knowledge from my association with the gifted and dedicated volunteers who worked to assemble that history, from John Wall to Marcia Phinney to Gene Moulton, along with many others. For a more linear view of Wakefield's history, I encourage readers to reference *Images of America: Wakefield*.

On a personal note, I would like to acknowledge the assistance of David Workman, Wakefield Historical Society curator, and Susan McDonough. This work has benefited from the invaluable assistance of my daughter, Rebecca Bertrand, and my husband, Joseph Bertrand.

The town of Wakefield has been blessed with a number of organizations actively working to preserve and protect its historical buildings. The Colonel James Hartshorne House Association protects the c. 1681 house by the lake, and the Americal Civic Center Association works to preserve the old state armory. I am happy to dedicate all of the author's royalties of this volume to the work of preserving and protecting the museum of the town of Wakefield. This volume will benefit the West Ward School Association and the Wakefield Historical Society.

INTRODUCTION

The Native Americans came here first. For more than 10,000 years, they inhabited the area now know as Wakefield. Two local lakes are remnants of a larger lake system that served as spawning grounds for fish 8,000 years ago. The native people who lived here hunted game and fished in streams and lakes; they gathered wild foods, cleared lands, and grew crops of corn, beans, and squash. Wakefield's recorded history begins with European settlements in the 17th century. In 1639, a mere 19 years after the landing of the pilgrims at Plymouth, hardy settlers would venture here from the settlement at Lynn. They established an "inland plantation" named Linn Village.

In 1644, when seven families had settled and seven homes had been built, the General Court ordered that the town might be incorporated. The town then included the present-day towns of Wakefield, Reading, and North Reading. The village, clustered around the shores of the Great Pond, later named Lake Quannapowitt, took the name of Redding. It was a community of farmers who took advantage of the crystal-clear streams and lakes, wild game, and verdant pasturelands. By 1667, the community boasted 59 homes. To guard against attack, a garrison house was constructed in 1671. In 1686, the settlers formally purchased their land from the Saugus Indians.

The town sent its share of men to the French and Indian Wars and to the Revolutionary War, but no battle was fought within its bounds. Townspeople responded to the call for men during the conflicts at Lexington and Concord, and a total of between 400 and 500 men would fight in the war that followed. The Old Burying Ground contains the headstones of many who fought during the American War of Independence.

By the late 18th century, the town had split into three parishes for religious worship and civil gatherings. Wakefield was the First Parish and the largest, the Second Parish was North Reading, and the present-day town of Reading was the Third Parish and the last. First Parish petitioned to be set off as a separate town as early as 1785, but a formal division was not made until 1812, when it was incorporated as the Town of South Reading.

A small and rural village at the time of its incorporation, South Reading was an isolated hamlet. The population numbered 800, with 125 residences on 16 public roads. The town grew slowly but steadily as families grew and prospered, farming the land and making shoes in cottage industries. All of this would change with the coming of the railroad. The Boston and Maine Railroad (B&M) ran a line through the town in 1845. The effect of the rail transportation was dramatic: The population doubled from 1,600 to 3,200 within 15 years.

The railroad transformed the town from a solitary village to a suburb of Boston. Quick rail transport gave new growth to the flourishing tin industry of Burrage Yale, as well as to the already important shoe industry. It also attracted a dynamic personality to the town: Cyrus Wakefield, whose ancestors had lived in the town, visited his sister at South Reading Academy and saw potential. He moved his burgeoning rattan industry to the town in 1855. By the time of his death in 1872, the town had been virtually transformed, both in terms of growth and industry, and also in name. In response to Cyrus Wakefield's donation of a new town hall, the town of South Reading, Massachusetts, had formally changed its name to Wakefield.

This volume explores the history of Wakefield using the wonderful paintings and photographic images owned by the Wakefield Historical Society. These include images of the town's buildings, businesses, and industries, as well as a view of the celebrations of community that are unique to the character of the grand old town of Wakefield.

One

FRANKLIN POOLE'S WINDOW ON THE 1800S

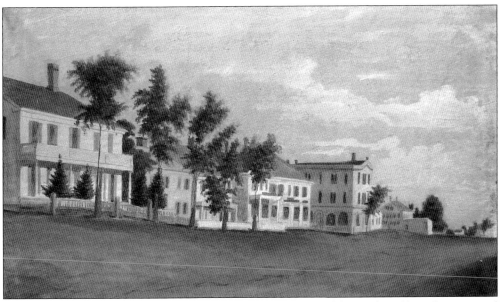

South Reading and Wakefield of the 1800s is captured by Franklin Poole, self-taught artist and native son whose paintings offer the contemporary viewer a unique window on his world. In this painting, Main Street is shown looking north from around Water Street. At left is the 1822 home of Solon O. Richardson, prominent citizen and patent medicine manufacturer. The large structure near the center is the Kingman Block, built in 1852. At far right is the home of Dr. Joseph D. Mansfield. The Congregational Church is just barely visible in the distance, at extreme right.

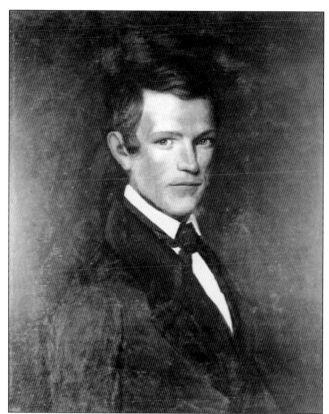

Franklin Poole was born in 1808. During his long and remarkable life he would serve as a house painter, an antislavery advocate, a newspaper publisher, and a state representative. A landscape painter by avocation, Poole chronicled his town with great care and precision.

"Wakefield has been fortunate to have a citizen who had the foresight to put on canvas, the scenes of his boyhood, which we, of later years, have never seen, and would not have seen, except through his paintings," wrote photographer and artist Joseph Payro around 1944. Franklin Poole grew up in this house on Salem Street. The residence was constructed prior to 1795 by Elias Emerson and purchased by Timothy Poole, the artist's father.

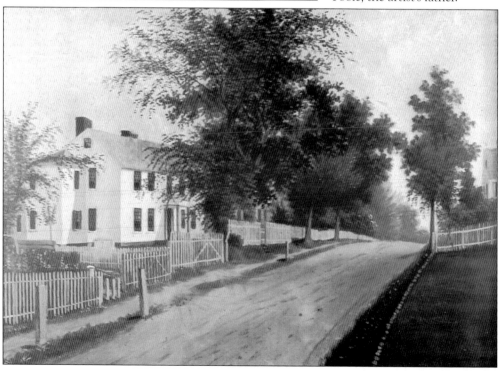

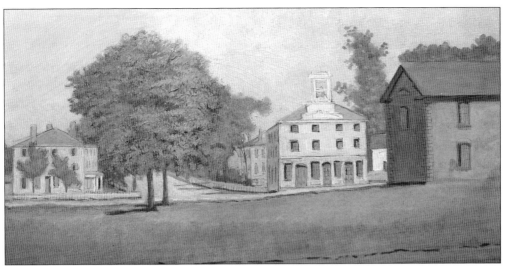

Pictured here is a view across the Lower Common, then known as "the Park," around 1874. At left, on the corner of Salem Street, is the Lilley Eaton house, constructed in 1804. This stately building became the center of population and trade in the early 1800s, serving as the village post office and principal store. It was razed in 1913. At the center of the painting is the relocated 1834 Town House, which was sold after the construction of the Cyrus Wakefield Town Hall. At right is the brick (fire) engine house.

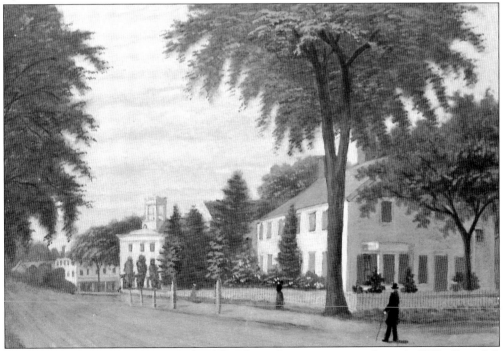

This unusual view shows the east side of the Upper Common prior to the early 1890s. From left to right are the Lilley Eaton house, the Town House, and the Andrew Young house. The Young house stood on the north corner of Main and Bryant Streets opposite the Common until the early 1890s. All buildings on the site were demolished before the Emmanuel Episcopal Church was moved there from Water Street in 1901.

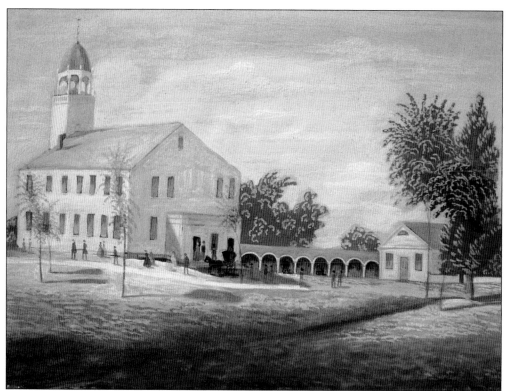

The third meetinghouse of the First Parish is shown prior to 1859. The structure was built in 1768, remodeled in 1837, radically remodeled in 1859, and taken down in 1890.

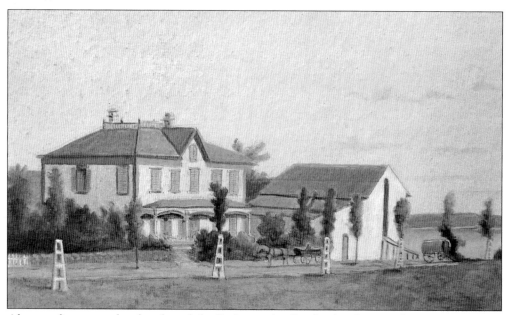

Almost adjacent to the church and the Park was the Cartland icehouse. The structure in the foreground is the Cartland family home, with the icehouse standing behind it, on the shore of Lake Quannapowitt.

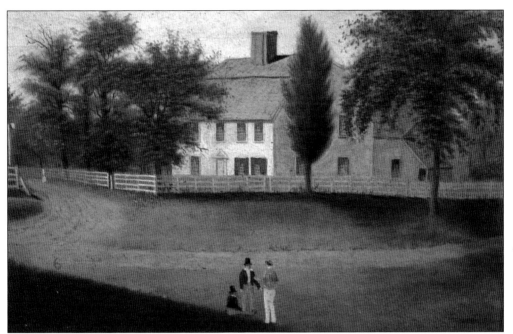

This painting shows the 1711 Caleb Prentiss house, named for the seventh minister of the First Parish Church. The Prentiss house stood across the street from the Common on the approximate location of the present Wakefield Town Hall. The house, which was substantially enlarged in 1739, was the second parsonage of the First Parish Church. It was formally sold to Reverend Prentiss in 1770.

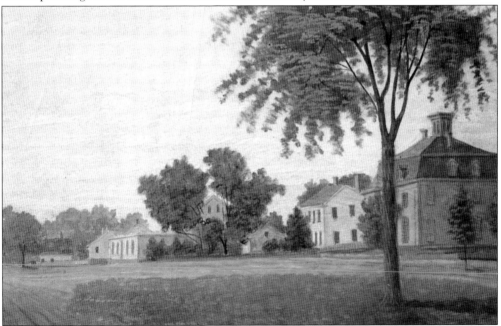

This view is down an unpaved Main Street from the location of the Rockery. The Town Common originally extended all the way down Main Street to approximately Water Street, on the path of a Native American trail. At far right are the homes of John White and Dr. Mansfield, a variety store, and beyond that, the residence of Solon O. Richardson.

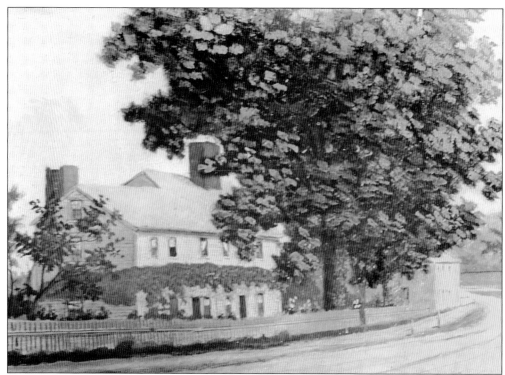

The Colonel James Hartshorne House is shown in this view. The residence, known as the Lafayette House for many years, is one of the oldest structures in Wakefield. Built before 1681 by Thomas and Mary Hodgman, it was later used as an inn by Dr. John Hart and was owned by the Hartshorne family from 1803 to 1884. This painting shows the hint of an additional building to the right of the Hartshorne House, probably an outbuilding used for the Hartshorne shoe business.

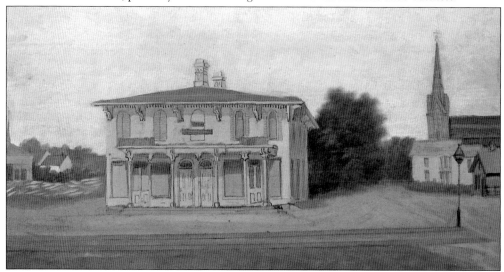

The old Bank Building on the corner of North Avenue and Albion Street is shown in this painting. Besides E. W. Eaton's store, the building housed both the South Reading Bank and the South Reading Mechanical and Agricultural Institution, a savings bank. Farther down Albion Street, to the right, is the Methodist church.

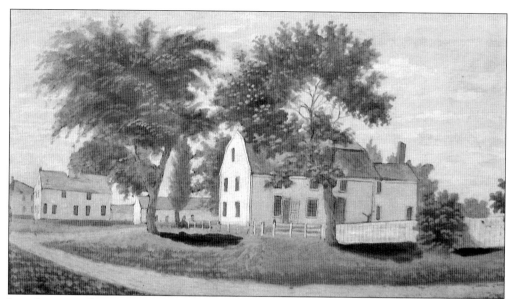

Long known as the Leonard Wiley house, this residence stood for many years on the northeast corner of Water and Crescent Streets. It was erected in 1785 and was moved to 35 Bartley Street in about 1890 to make room for the construction of the Crescent House hotel and rooming house.

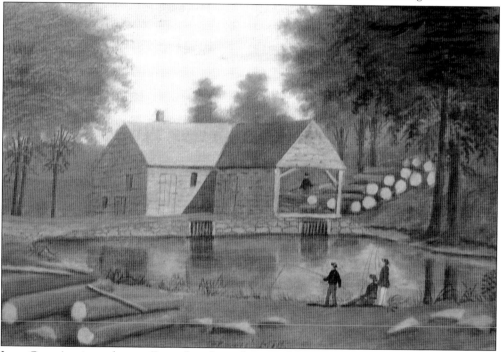

Jerry Green's grist and sawmill stood at about the site of the Wakefield Rattan Factory, on a line with Wakefield Avenue. The hill pictured at right is now Water Street. After waterpower was used in the sawmill, it was reused at the rattan factory, and finally the stream connected with the brook on to the Saugus River. According to local lore, the mill was later used as a cider mill. Joseph Payro remembered the waterwheel standing near Water Street in the Heywood-Wakefield yard in 1872.

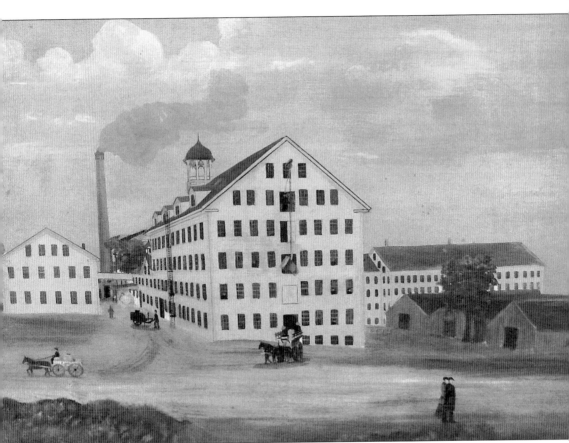

The locally important Wakefield Rattan Factory is pictured here prior to 1881. Cyrus Wakefield moved his rattan factory to the village, then known as South Reading, in 1855. By the 1870s, it would employ 1,000 persons.

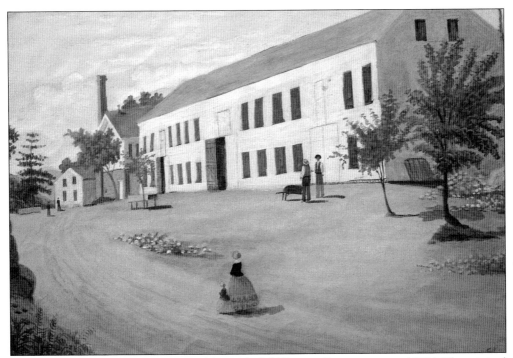

This is the earliest known depiction of the Wakefield Rattan Company around 1856. The original wooden factory building is shown. One of the company's earliest products was hoops for ladies' skirts, similar to the one undoubtedly worn by the woman in the foreground.

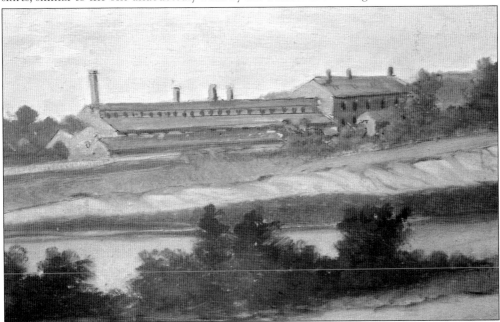

Cyrus Wakefield, consummate entrepreneur, had many and varied business interests both in Wakefield and Boston. One of his ventures was the Boston and Maine Foundry, later purchased by the Smith-Anthony Stove Company, which became a major U.S. iron manufacturer. This Franklin Poole view of the foundry was painted after 1879.

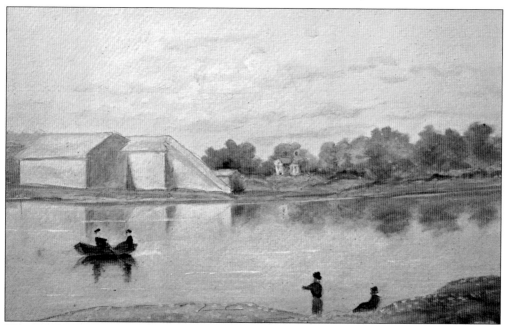

The ice industry was tremendously important to Wakefield beginning in about 1860 and continuing until the dawn of refrigeration. Ice harvested in Wakefield was shipped worldwide. In this view, Franklin Poole depicts an icehouse on Crystal Lake.

Harriet Flint's residence is pictured here. A true daughter of South Reading and a member of the Evans family, she made her home in North Reading during her married life. Following the death of her husband, Harriet Flint cared for his business interests and moved back to Wakefield, where she lived on the present-day Hart's Hill. Charles Street is named after Harriet Flint's husband.

One of the oldest structures in Wakefield is shown here. Part of the Caleb Green house, now located at 391 Vernon Street, was constructed in Lynnfield in the early 1600s. Caleb Green acquired the home around 1790 and moved it to its present site in Wakefield. At one time the Green property included nearly 30 acres of land to the west. The land remained rural and primarily agricultural until the 20th century. The farmhouse has been moved and renovated, but its early ell remains, as well as the *c.* 1750 addition.

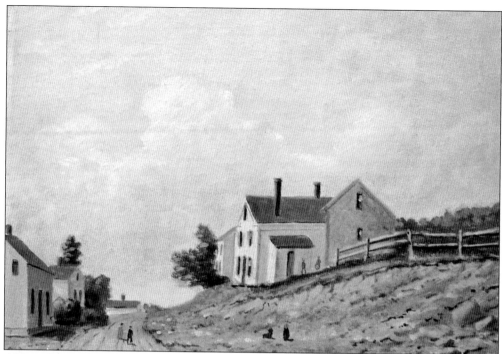

Although Franklin Poole painted many views of downtown Wakefield, he also visited other areas. This view shows Valley Street, looking south, in about 1884.

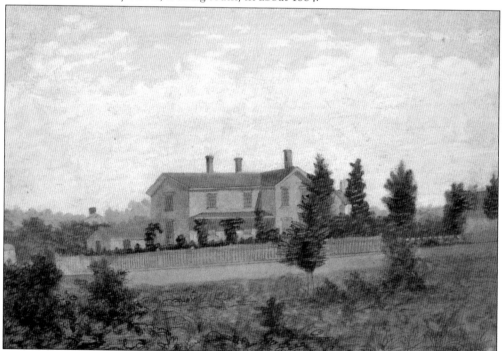

This view shows Greenwood in 1874. The Bicknell house faces east, and the Paul Hart Sweetser House is located to the left. In the far distance, Myrtle Avenue can be seen. The Greenwood Seminary is just barely visible at right.

Two

GONE BUT NOT FORGOTTEN

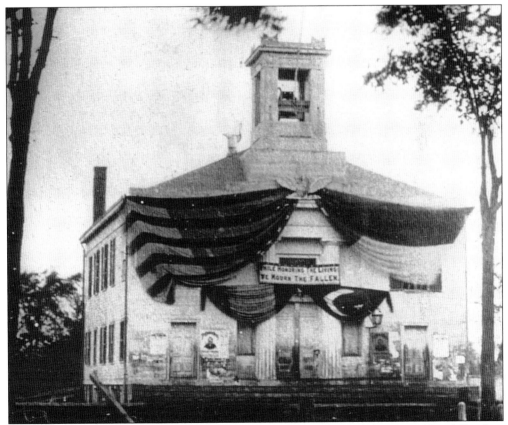

The wooden Town House was built on the Common in 1834. It served the town of South Reading as the center of government until the brick Town Hall was donated by Cyrus Wakefield. In this very old photograph, the structure is draped for Civil War observances. The banner spanning its columns proclaims, "While Honoring The Living / We Mourn The Fallen."

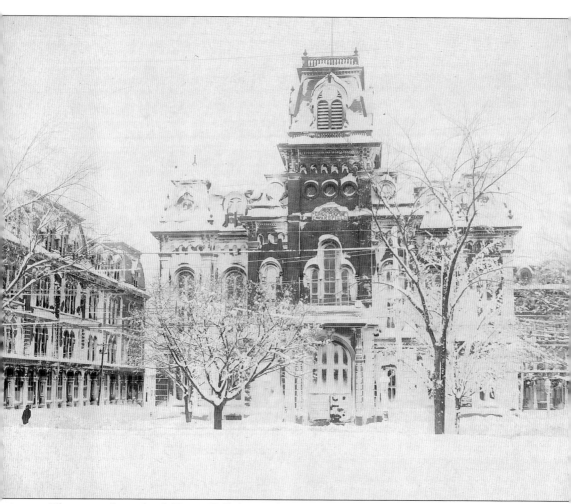

The magnificent brick Town Hall donated to the town by Cyrus Wakefield is shown in this photograph. After World War II, the town began investigating the possibility of replacing or remodeling Town Hall and building a separate police station. In 1946, a subcommittee was appointed to investigate the remodeling. In 1950, a separate police station was built. On the evening of December 12, 1950, a small fire began in Town Hall, but was quickly put out. Insurance covered half of the $90,000 damage. In lieu of repairing Town Hall, town meeting voted to spend more than $2 million on an addition to the high school, but no money was spent repairing Town Hall—not even the insurance money.

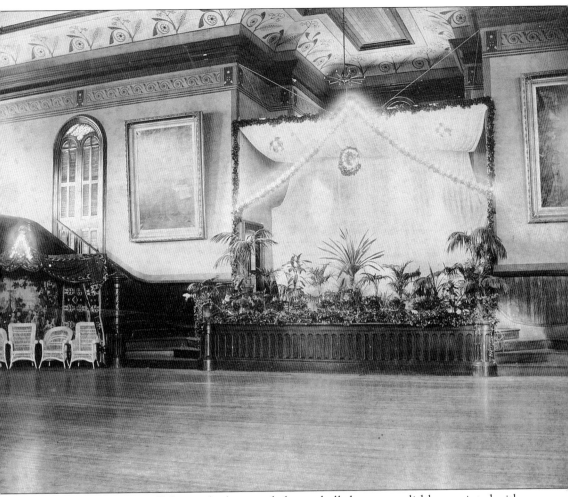

The interior of Town Hall featured a large and elegant hall that was stylishly appointed with Aesthetic Movement designs near the ceiling. Portraits of Cyrus Wakefield and George Washington flanked the stage. The building was used for public meetings, gatherings, and performances. Wicker chairs populated the hall, which is pictured as prepared for a Masonic gathering.

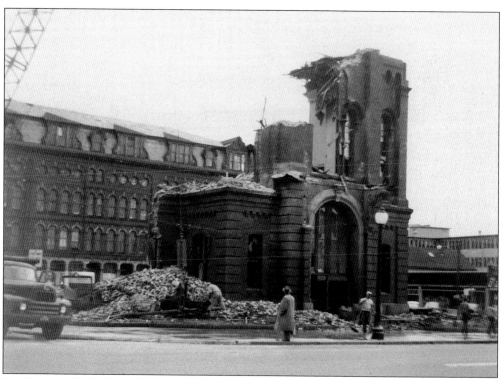

On October 20, 1958, the Town Hall donated by Cyrus Wakefield was demolished.

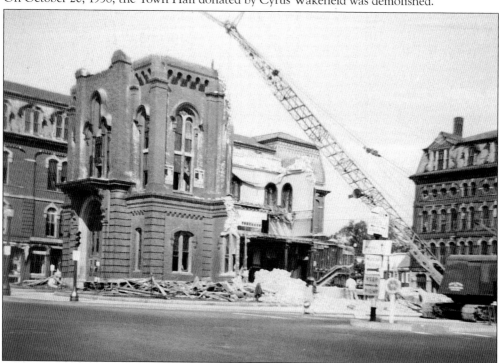

Once called "munificent and fair," the building was so well constructed that it took most of the day to tear it down.

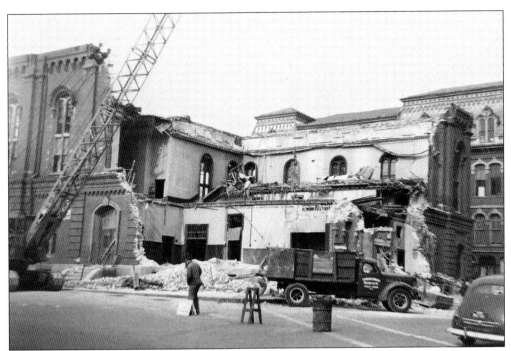

Ample and stylish, Town Hall was large enough to house many town departments, including the police department and library at one time. Since its demolition, the town has repeatedly lamented the need for additional meeting rooms and performance space.

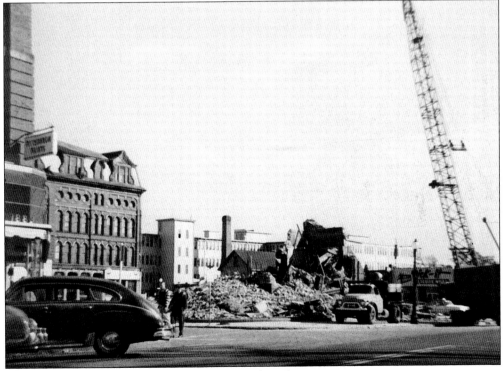

Where Town Hall once stood, there is now a parking lot.

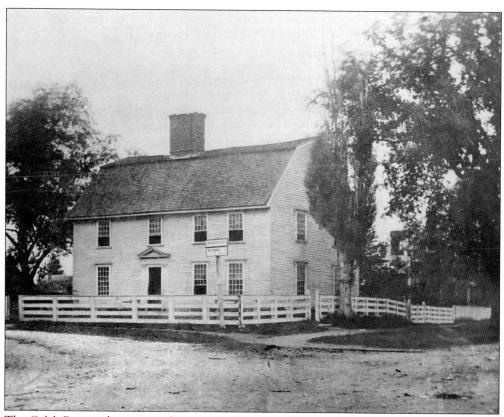

The Caleb Prentiss house was photographed between 1868 and 1870 by C. F. Richardson. The house stood on the northwest corner of Lafayette and Common Streets and was occupied by Rev. Caleb Prentiss, seventh minister of the First Parish Congregational Church, from 1769 to 1803. The house was moved to Traverse Street in order to make room for the construction of the high school in 1871 (now Town Hall). The home stood on Traverse Street for many years but, after several fires, was finally demolished.

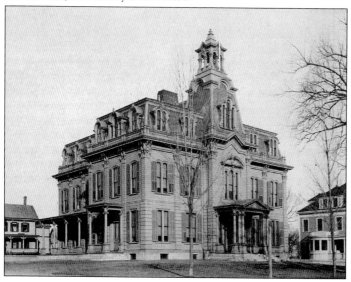

The Lafayette High School building was erected in 1871 on the site of the Caleb Prentiss house. It would serve as the high school until construction of the new school building in 1923 and would continue to serve as an educational facility until 1936, at which time the school department transferred its ownership to the town.

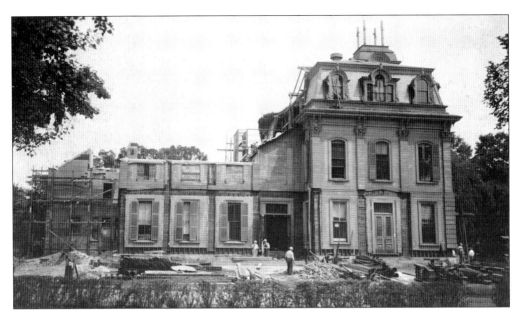

In 1937, the town received federal WPA funds and decided to modernize Town Hall. Crews removed its Italianate features and faced it with brick.

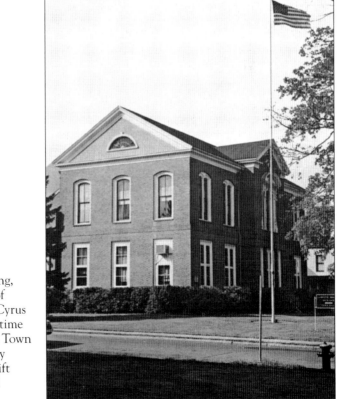

Known as the Lafayette Building, the structure served a variety of uses until after the fire in the Cyrus Wakefield Town Hall. At that time the Lafayette Building became Town Hall. It received an accessibility overhaul and substantial face lift in 1998 and has been renamed the William J. Lee Town Hall.

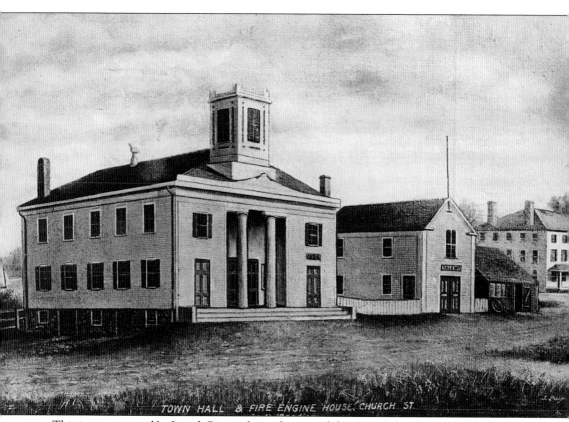

TOWN HALL & FIRE ENGINE HOUSE, CHURCH ST.

This image, painted by Joseph Payro after a photograph by C. F. Richardson, shows the structures on the Common around 1860. They are, from left to right, the old Town House, the Yale Engine House, and Bryant's blacksmith shop. The Eaton house is at far right.

The Yale Engine House, built in 1852 at a cost of $970, suffered a fire and was burned beyond repair on September 30, 1859.

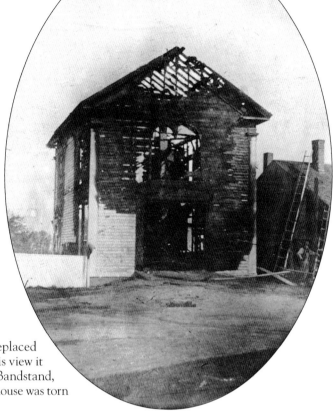

The Yale Engine House was replaced by a brick version in 1859. In this view it can be seen in relation to the Bandstand, built in 1885. The brick engine house was torn down in 1891.

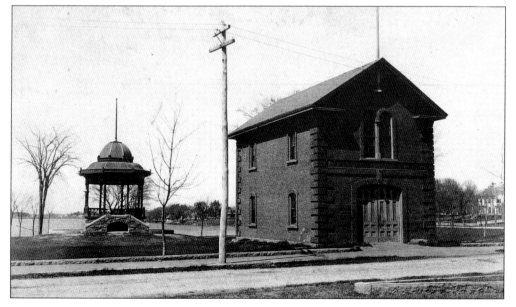

The Volunteer Hose No. 2 station on Foster Street was built in 1900. Volunteer Hose No. 2 was abolished by the fire department in 1920, but the structure remains in place on Foster Street and is privately owned. It is shown in this photograph with the old South Reading Academy Building (right). The academy building was originally on the site of the Lincoln Schoolhouse and was moved to this location and used as the Grand Army of the Republic Hall for many years.

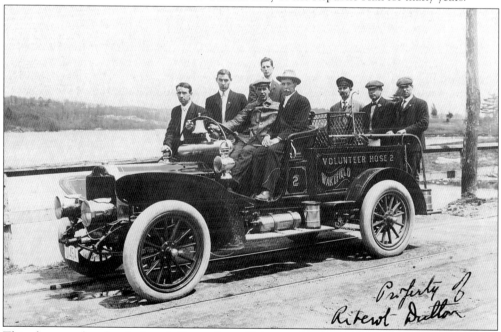

This photograph, taken by Joseph Payro, shows Volunteer Hose No. 2 apparatus and its members in May 1908 near the Saugus Reservoir. Joseph Hughes was the chauffeur; Charles Pope is at his left. Crozier Latimer, Albert Kent, and George Zwicker are on the back steps of the machine.

This photograph shows the old Central Fire Station on Crescent Street, at the corner of Mechanic Street (now Princess Street). The building, a former schoolhouse, was moved to this site in 1891. Bricks from the demolished Yale Engine House on the Common were used for its foundation. The fire station would ignite during the Hathaway stable fire on October 23, 1899, and was ultimately taken down.

This rare image shows the old North Ward School (also known as the first Woodville School). In 1847, four identical schoolhouses were built to serve the four "wards" of the town. The North Ward School would be taken down, and a new Woodville School was built in 1920, to be replaced, in turn, by the present Woodville School.

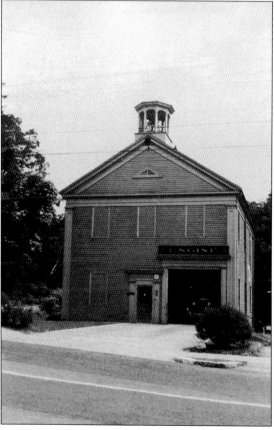

The South Ward School, originally built on the east side of Main Street just south of Meriam Street, was moved to Oak Street in 1858. In 1902, it was pressed into service as a fire station serving Greenwood. The building was taken down in favor of a more modern station in 1962. The sole remaining Ward School building is the West Ward School, which has become the town's museum.

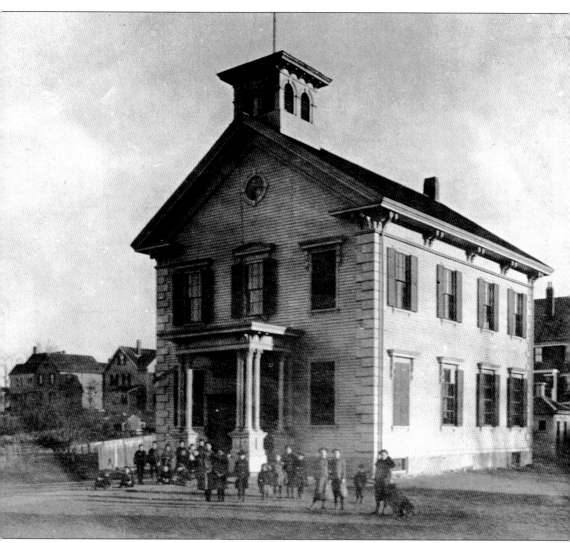

This is an extremely rare photograph of the original Franklin School, built on Franklin Street in 1871. In 1902, it was replaced by the new Franklin School on Nahant Street. In 1911, the original building was deemed no longer usable as a school due to flooding in the cellar. The town sold the school building itself for the sum of $85 in 1913.

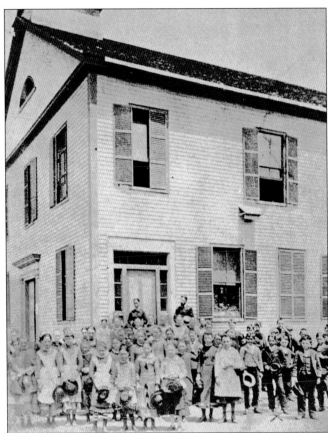

This rare view shows the Center Schoolhouse on Academy Hill about 1876. The schoolhouse would later become the Central Fire Station. Academy Hill, now the site of the Lincoln School, housed the South Reading Academy Building as well as the Center Schoolhouse.

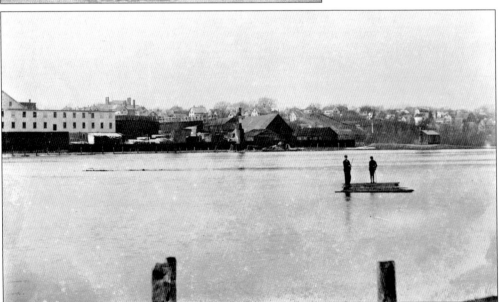

This photograph presents the view from 87 Water Street, showing the flooded field, now the Nasella Playground. The old Montrose car line was being built at the time and can barely be seen above the waterline. The building on the small knoll at right is the old rifle range.

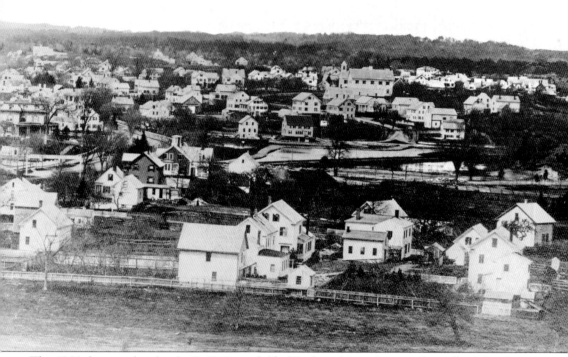

This 1866 photograph, taken by D. W. Butterfield of Roxbury, Massachusetts, shows South Reading from Hart's Hill, with Center Pond at center of the view. D. W. Butterfield achieved renown for his portraits of Abraham Lincoln, Ulysses S. Grant, and other nationally important individuals, and it is believed that he expertly captured this scene in two sections in order to make the image of Center Pond clearer. Local artist and photographer Joseph Payro wrote the following explanation of the process: "The photographer coated his plates in a Cobbler Shop at the bottom of the hill. But when he got to the top of the hill, his plates were too dry for exposure. So he built a temporary 'dark room' on the top of Hart's Hill and got a fine set of negatives."

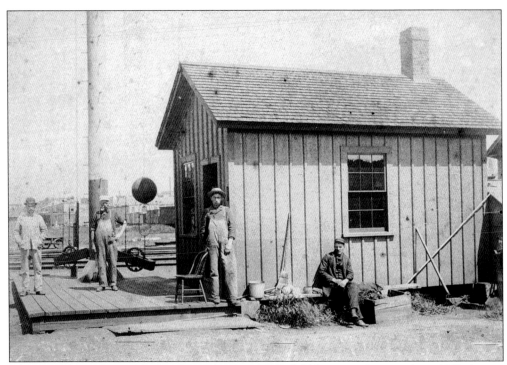

This view shows the toolshed and signal pole at Wakefield Junction Station about 1910. At one time the town had six separate railroad stations: three on the main line of the Boston and Maine Railroad, two on the Danvers and Newburyport Branch, and one on the South Reading Branch of the eastern road to Salem.

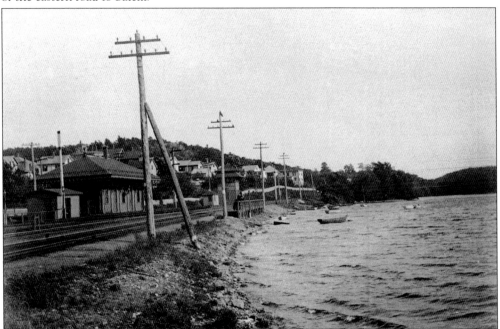

This c. 1890 image shows the Junction Station, with Smith Pond (Crystal Lake) in the foreground. The photograph was taken by Cyrus Wakefield III.

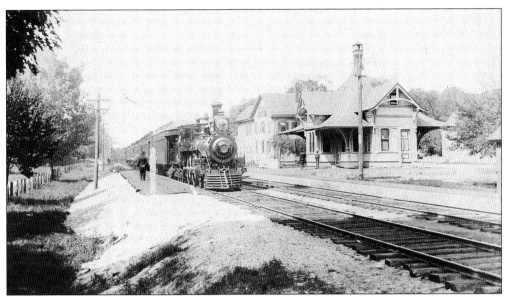

The Greenwood Station is shown in 1885. The station was later sold to the Pleasure Island amusement park and was transported there, where it would burn to the ground on April 1, 1971.

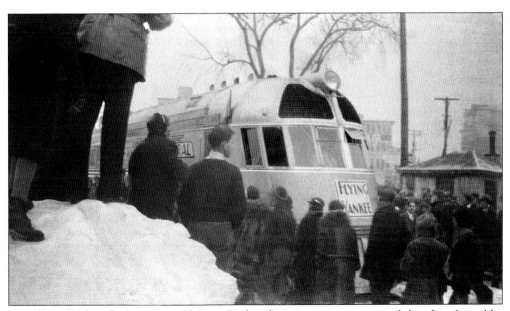

The *Flying Yankee*, the Boston and Maine Railroad's signature train, was exhibited to the public at Wakefield's Center Station while on a run to Portland, Maine, in the 1930s.

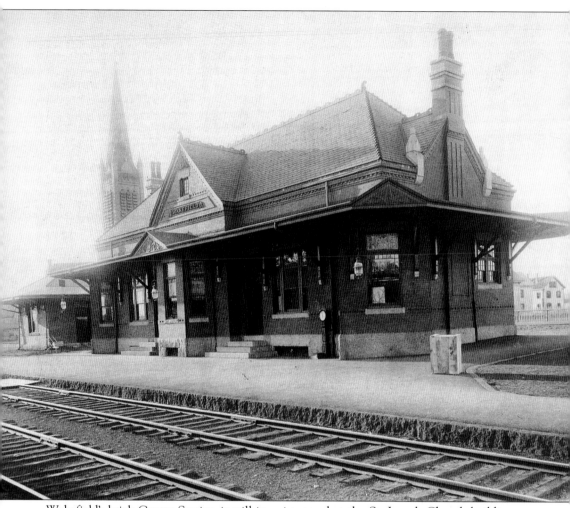

Wakefield's brick Center Station is still in existence, but the St. Joseph Church building seen behind it has been replaced by a modern structure.

This postcard shows St. Joseph's Catholic Church. Originally established in 1871, the church was enlarged and revised in 1889. It burned to the ground on March 14, 1977.

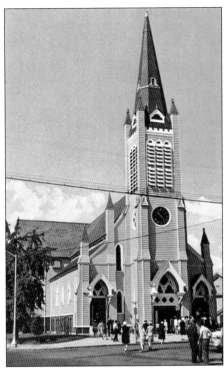

The magnificent interior of St. Joseph's Church is shown in this 1908 photograph.

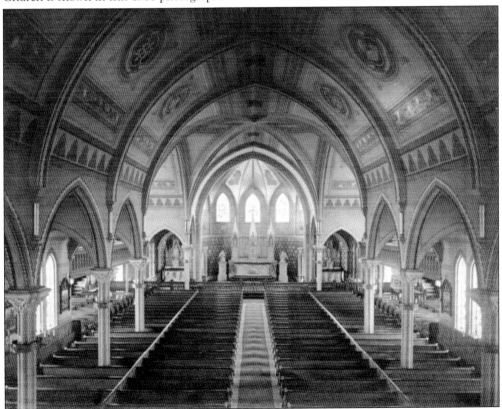

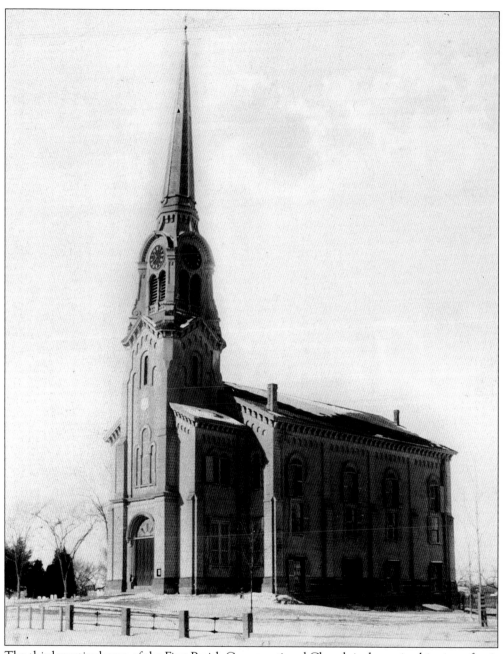

The third meetinghouse of the First Parish Congregational Church is shown in this view after it was moved and remodeled in 1859. The building was replaced by a new church in 1890.

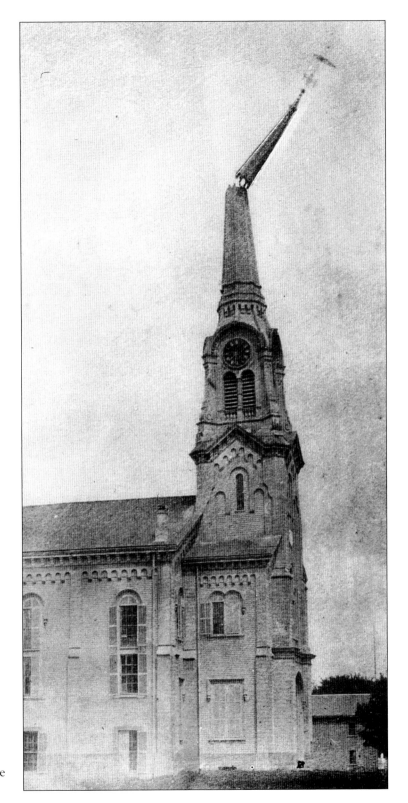

This unusual view shows the steeple of the First Parish Church being taken down as part of its demolition in 1890. The steeple was dragged down by a number of men pulling on a rope fastened three-quarters of the way up its shaft, after carpenters had partially sawed through the structure to weaken it.

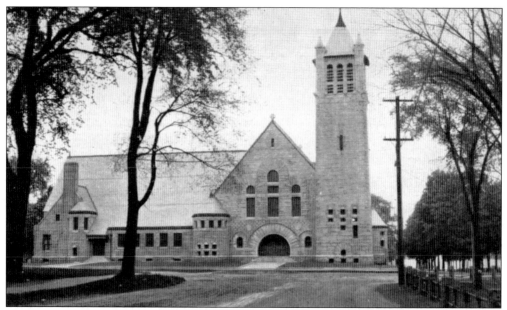

The fourth meetinghouse of the First Parish was a fine stone building. Designed by the Boston architectural firm of Hartwell and Richardson in the Richardsonian Romanesque style, the structure was thought to have more permanence than a wooden church building.

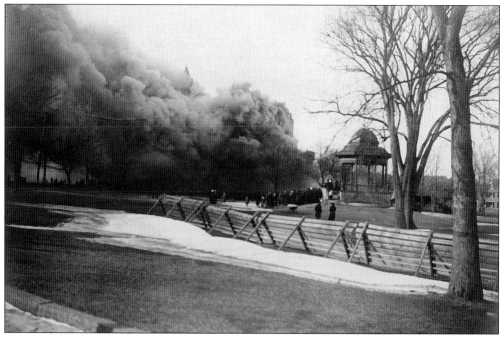

On February 21, 1909, a fire tore through the new stone First Parish Congregational Church in a blaze that was so hot that ash from the burning leaves of hymnals rained down upon onlookers.

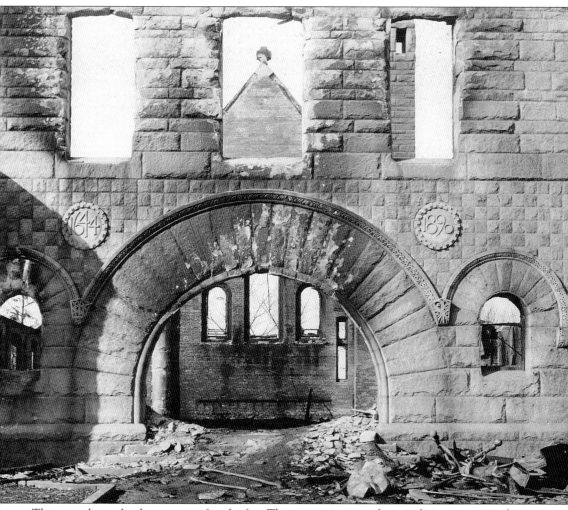

This view shows the devastation after the fire. The congregation took immediate action to replace the building. A new church, composed of two shades of gray granite from Monson, Vermont, with a gray slate roof, was designed by Hartwell, Richardson, and Driver and was dedicated in 1912.

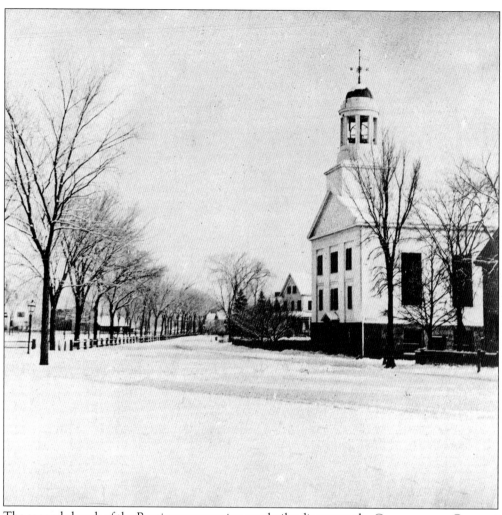

The second church of the Baptist congregation was built adjacent to the Common near Crescent Street in 1837. This new church replaced an earlier building on Salem Street that had been destroyed by fire in 1835.

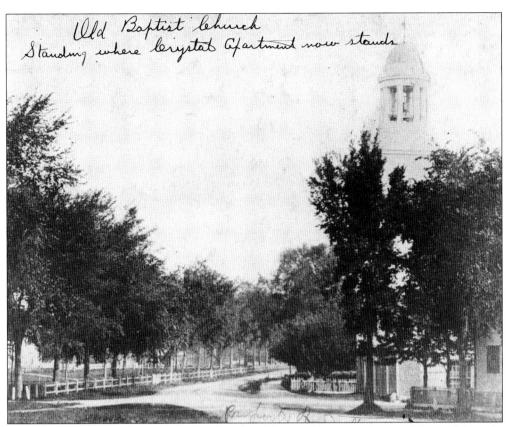

Old Baptist Church Standing where Crystal Apartment now stands

This is a second view of the old Baptist church at Main and Crescent Streets. It burned down in 1871 and was replaced in 1872 by a beautiful Italianate structure located across the Common.

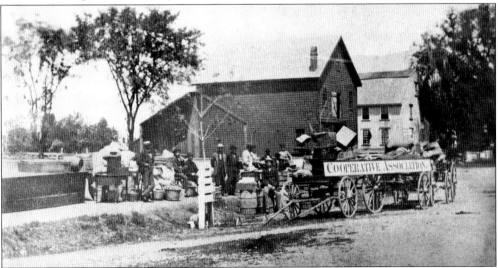

This view shows what was salvaged from the 1837 Baptist church after the fire. The stable in the background was removed to Centre Street and became the property of E. I. Purrington. Purrington used the second floor as a machinist shop; a blacksmith named Thomas E. Giles used the first floor. The building was torn down in 1933.

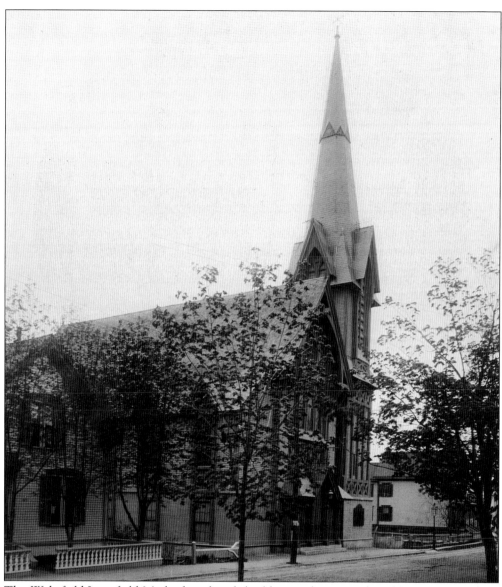

The Wakefield-Lynnfield Methodist church building is shown in this photograph. Located on Albion Street, the church was constructed in 1874. After surviving three lightning strikes over the course of 50 years, the steeple was finally felled by the Hurricane of 1938. The entire structure, weakened by the damage to the steeple, had to be leveled. A new church home was built on Vernon Street.

This *c.* 1885 photograph shows an unusual view of Albion Street when it was more residential and rural in character.

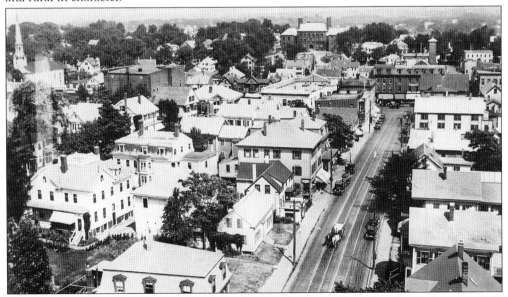

This view of Albion Street was taken from the steeple of the Methodist church between 1924 and 1938.

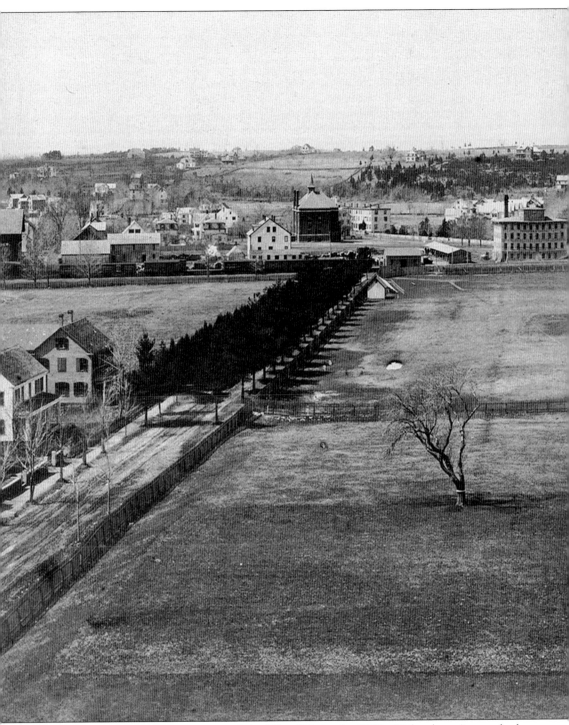

This photograph shows a view toward the West Side in the 1890s. Richardson Avenue had not yet been laid out; West Water Street, with a line of dark shade trees, is visible to the left. At the end opposite the shade trees is the Hamilton School, Wakefield's first brick school, located on Albion and Lake Streets. The open area in the center is the property of S. O. Richardson. Just

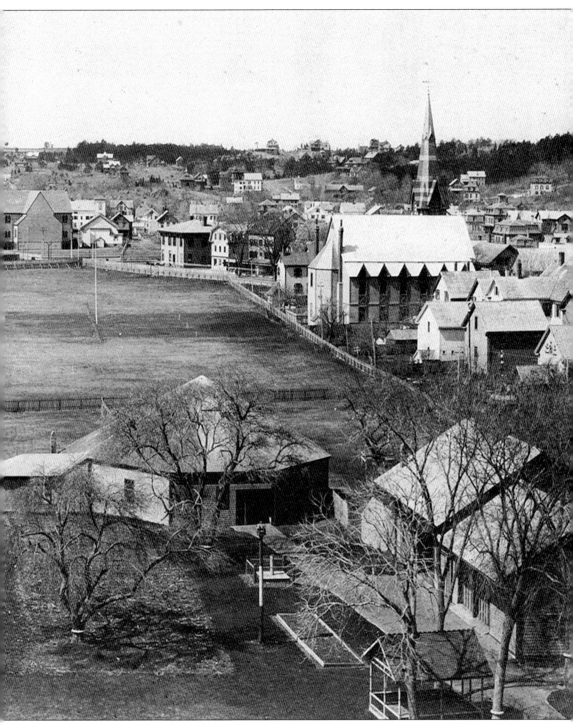

beyond the field are the Osgood shirt factory and several other commercial buildings. Of chief interest is the old roundhouse, which is used as a stable for carriage horses and racehorses, possibly run at the old Wakefield-Reading Fairgrounds.

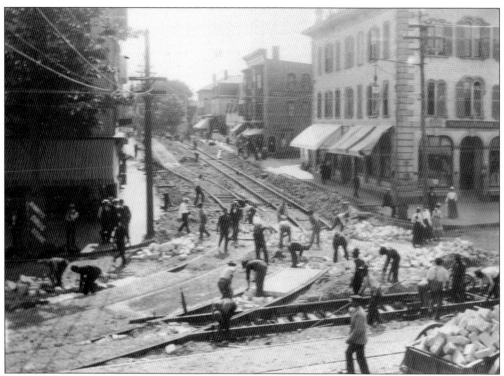

In the age of the trolley, this view shows Albion Street being double-tracked to allow more efficient use of the streets.

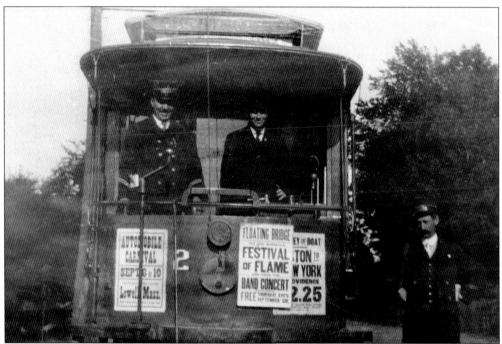

Albert Kenrick, John Sullivan, and George Young serve on this trolley, which advertises a "Festival of Flame" as well as an "Automobile Carnival" in Lowell, Massachusetts.

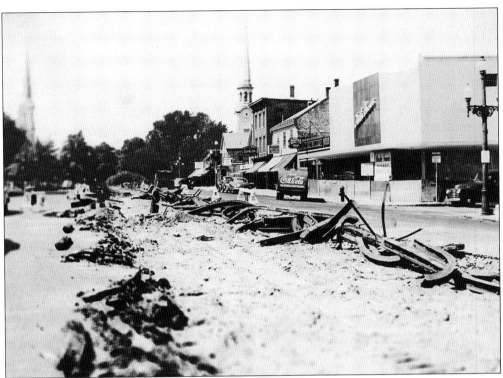

In 1949, the electric tracks were removed from the Upper Square in front of the Parke-Snow building. Note the decorative streetlights lining Main Street.

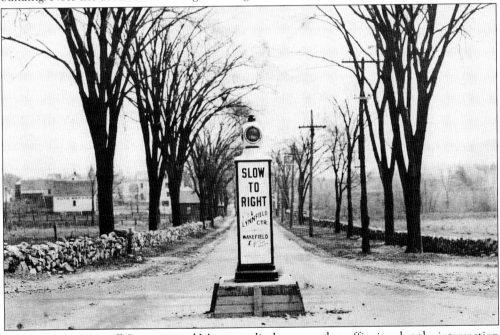

This view along Lowell Street toward Montrose displays an early traffic signal at the intersection of Lowell and Vernon Streets with arrows directing travelers toward both Lynnfield Center and Wakefield.

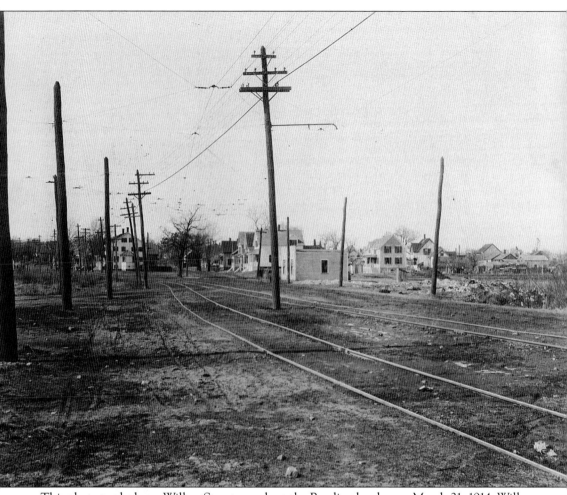

This photograph shows Willow Street, nearly at the Reading border, on March 21, 1914. Willow Street was once called Railroad Street and is now North Avenue.

This undated photograph shows the northeasterly view from Curve Street. Icehouses are shown on both edges of the photograph. At right are the Morrill-Atwood Ice Company houses, which were purchased by Porter Milton Ice Company in 1923. The icehouse visible at left is probably the property of the Wakefield Ice Company.

This is how North Avenue looked in 1934. Looking northeast, the Wakefield Municipal Gas plant is at left and straight ahead (in the present location of Hall Park) is the icehouse of the Wakefield Ice Company, owned by William H. Hall.

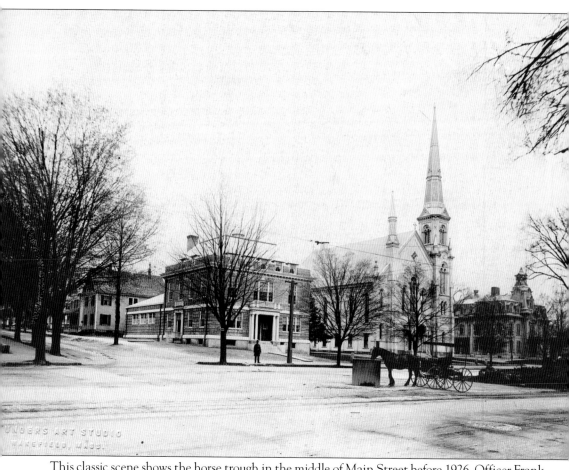

This classic scene shows the horse trough in the middle of Main Street before 1926. Officer Frank Robinson can be seen in front of the YMCA building. The horse and team were owned by Albert Phinney, who delivered milk.

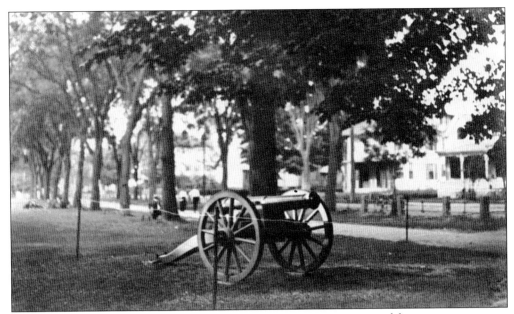

A Civil War cannon that once adorned Wakefield Common was removed for repairs many years ago and has not been seen since.

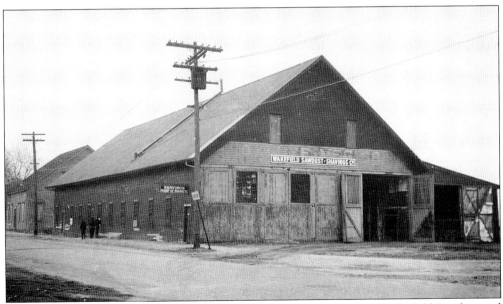

The old streetcar barn on Water Street eventually became the home of Wakefield Sawdust and Shavings Company, seen here in 1937. The building burned down in 1938.

The *c.* 1752 Swain house stood on Vernon Street, near Reid's Corner. This house was erected by members of the fifth generation of Swains in this town. An ancestor included Maj. Jeremiah Swain, born in 1665, who commanded troops in the French and Indian Wars.

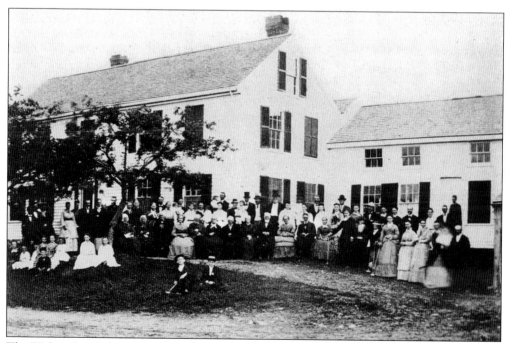

The Walton family home stood on the north side of Salem Street, just east of Route 128. It was removed to make way for the highway. This view shows a Walton family reunion.

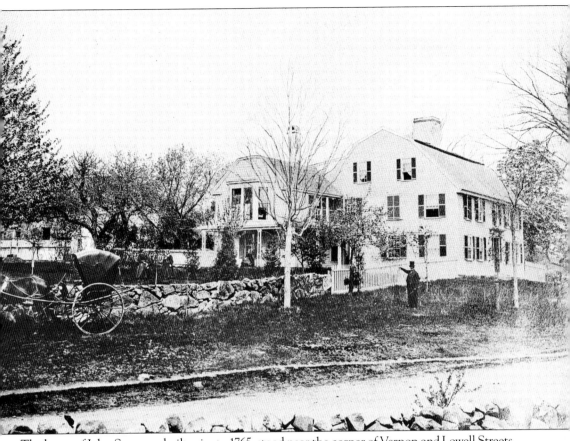

The home of John Sweetser, built prior to 1765, stood near the corner of Vernon and Lowell Streets. The house was later owned by Dr. Robert W. Cushman, a retired Baptist minister, who appears in the foreground of this photograph. The residence was destroyed by fire in 1868.

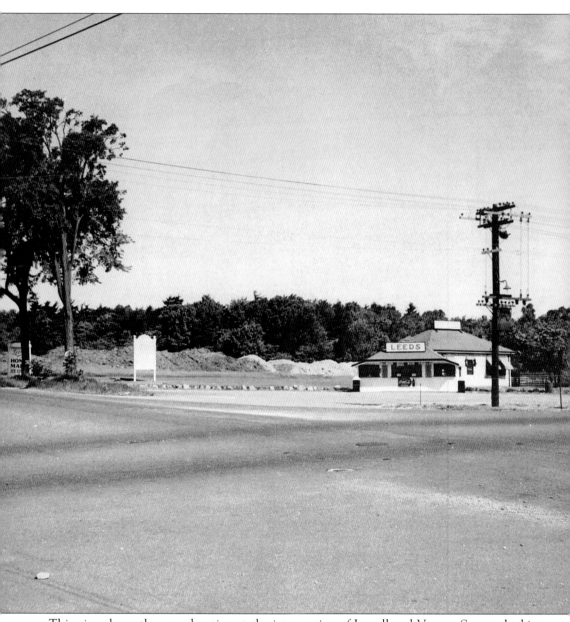

This view shows the same location at the intersection of Lowell and Vernon Streets, looking northwest. Leed's ice cream stand would later be replaced by a gas station.

At the northeast corner of Lowell and Vernon Streets was the homestead of Joseph Underwood, built prior to 1740. Later the residence of the late Moses P. Parker, it was purchased in 1920 and became part of the Elk Spring Bottling Company.

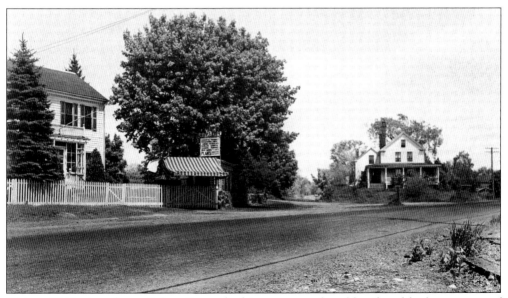

This *c.* 1945 view shows Salem Street looking east on the old railroad bed, now part of Route 128.

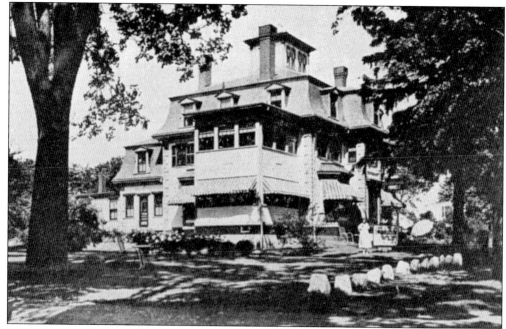

Menu items at the Lynnbrook House restaurant, located at 327 Salem Street, included "native chicken, thick steaks, fresh lobster and tasty waffles with Vermont maple syrup." An advertisement announced, "All home cooking, service at all hours, special daily $1.00 dinners and special Sunday dinners."

This 1885 view shows a sawmill on the Saugus River at the Wakefield-Lynnfield line on Vernon Street.

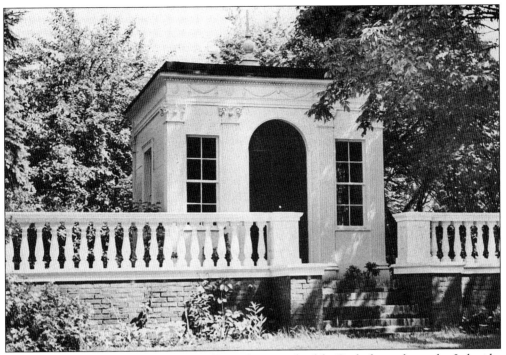

This charming summerhouse was originally on the grounds of the Beebe house located at Lakeside. Once owned by Lucius Beebe, the house is located at 142 Main Street and was probably erected between 1798 and 1818. The Beebe house, thought to have been designed by Samuel McIntyre of Salem, has a classic beauty that was echoed in this outbuilding.

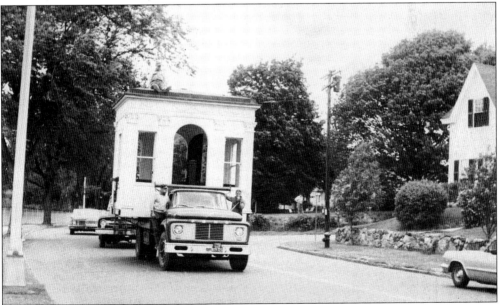

In the 1953, the owners of the Beebe house donated the summerhouse to the Colonel James Hartshorne House Association, which later donated it to the Essex Institute and Peabody Museum in Salem, where it can be visited on the grounds of the Peabody Essex Museum. In this photograph, the structure is being transported to the Hartshorne House grounds.

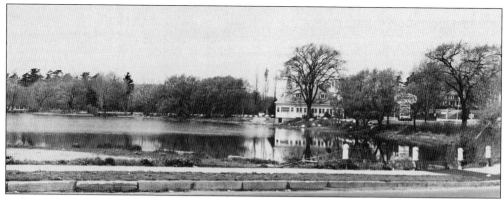

A fixture at the head of the lake for many years, the Howard Johnson's restaurant was owned by Pasquale De Cristofaro, who later purchased the nearby Walton estate.

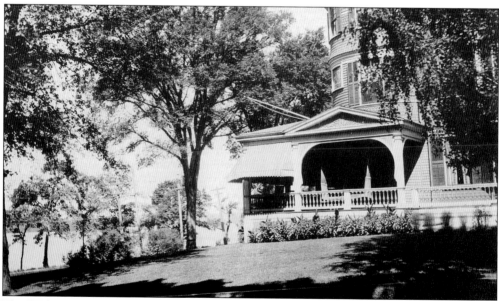

The Walton estate at Lakeside was, at one time, a showplace near the lake. The land housed the original homestead of John Brown, Esq., and was later owned by James Gould, Aaron Foster, Francis P. Hurd, Thomas Martin, and finally, Arthur G. Walton. It was destroyed by fire in 1940, shortly after the house and the land around it were purchased for development. Francis P. Hurd was the man for whom the Hurd School was named. Arthur Walton was a prominent citizen and a well-known manufacturer in Chelsea.

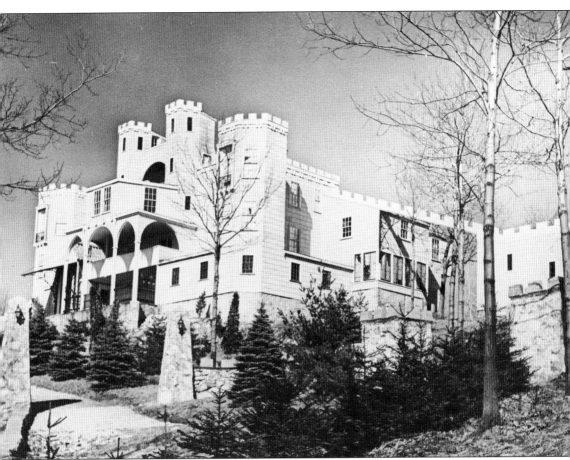

Rising on an eminence near the eastern border of Greenwood, Castle Clare was the work of Clarence Hoag. Born Clarence Hogg in Nova Scotia in 1870, he moved to Boston and established the Hoag Press. Hoag bought a house at 3 Acorn Avenue, but he wanted more—he wanted a castle. In 1922, he began building this extravagant residence, and by 1949, it was complete. Clarence Hoag was the architect and builder of the structure, which appeared very large because of its placement and the taper of its walls. It took 27 years to complete, and its exterior was coated in gray asbestos shingles, which looked remarkably like stone from a distance. The main feature of the interior was a baronial hall with a balcony for an orchestra, plus additional balconies. The living quarters comprised 18 rooms, arranged on both sides of the hall. The house had many staircases and more than 100 windows. After Hoag's death, the structure was divided into apartments. It burned down in 1974.

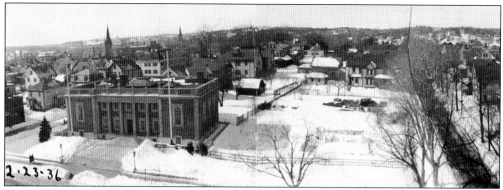

This view shows the site adjacent to the library, standing empty in readiness for the construction of the post office, which would be built there in 1936. In preparation for the new building, the c. 1830 residence of Frank and Grace White was moved to the Pleasant Street end of Aborn Avenue. The new Wakefield Post Office was designed to harmonize with the appearance of Beebe Memorial Library.

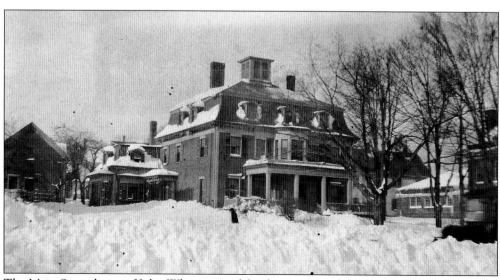

The Main Street home of John White, moved for the erection of the post office, is seen here in a 1926 photograph.

Three

GETTING DOWN TO BUSINESS

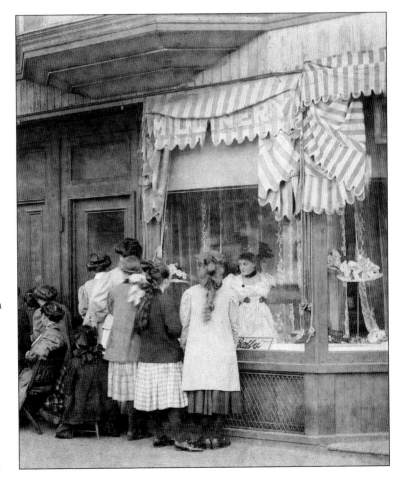

Shop windows have long held fascination for young women, and these young ladies are captivated by the wonders inside Nellie Gaffney's millinery shop around 1900. Posters in an adjacent window advertise a baseball game against Salem.

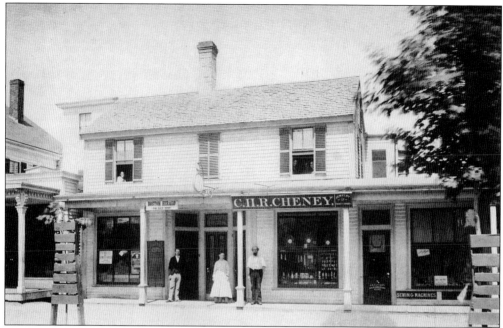

Capt. Charles Cheney's store stood on the east side of Main Street in the 1860s. Cheney began his merchandising career with the sale of shoes, but would later sell his shoe business and undertake the sale of "Jewelry and Fancy Goods." A poem on the inside of an early Cheney advertising circular lets the potential buyer know that "if you have hair from a soldier slain / He will put it in a locket and engrave the name." The flyer also included a long list of references. It is, of course, essential for a jeweler to be trustworthy!

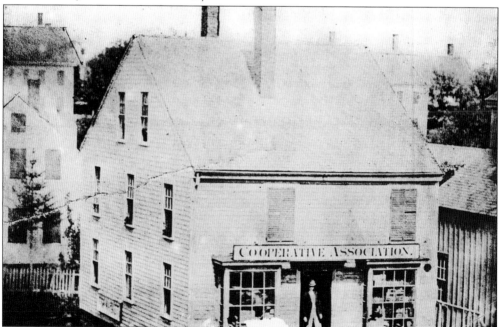

The Cooperative Association shop stood on the east side of Main Street, equidistant between present-day Lincoln and Centre Streets.

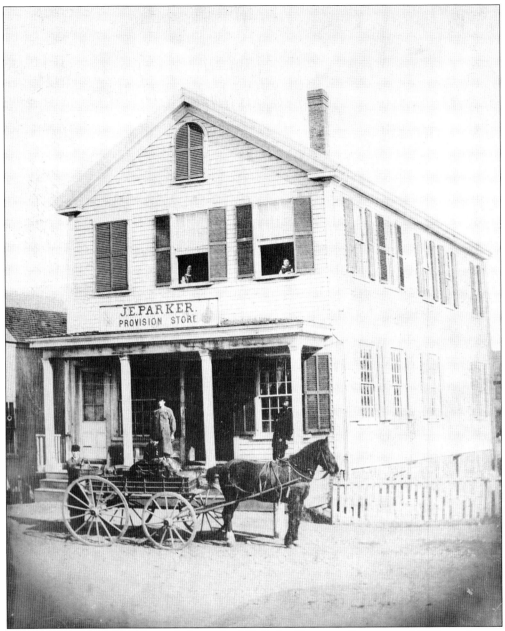

This C. F. Richardson photograph shows the J. E. Parker Provision Store around 1865, on the east side of Main Street, which was populated by simple Greek Revival frame buildings at the time. Only one such structure still remains.

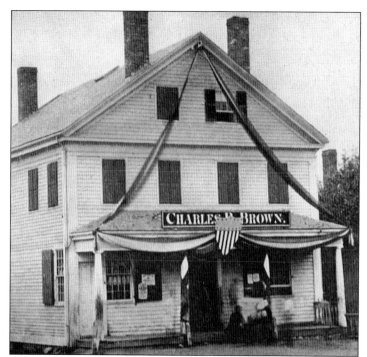

The Main Street shop of Charles Brown is shown here just after the Civil War adorned with decorations to welcome returning soldiers at the end of the conflict.

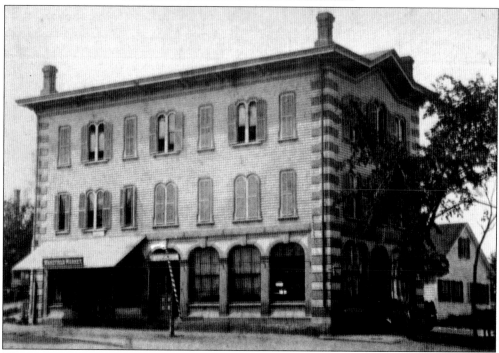

This *c.* 1860 view shows the Kingman Block at the corner of Main and Albion Streets. Tyler's Barbershop was located on the second floor. A. W Ventreas, the printer, occupied a corner room. The Ancient Order of Hibernians had the upper floor for years. Deadman's Market was on the ground floor, and the post office also occupied the building for some time. The building, much altered, is now named the Bourdon Building.

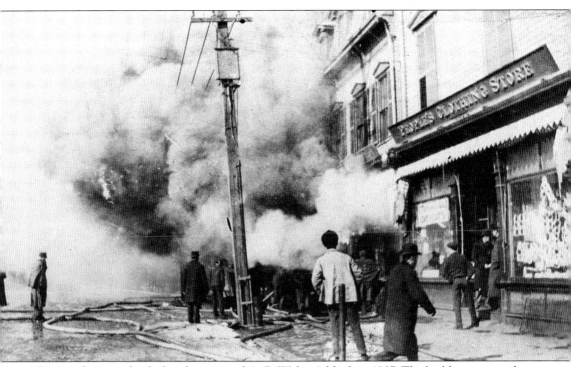

This is a photograph of a fire that ravaged A. B. Walton's block in 1907. The building was on the corner of Main and Mechanic Streets and housed People's Clothing Store.

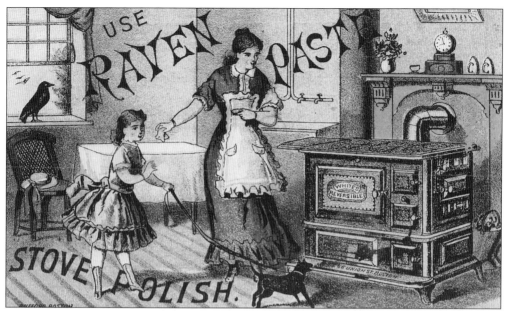

This advertisement for Raven Paste stove polish was issued by Cutler Brothers, who were "Wholesale and Retail Dealers" in groceries, flour, grain, and other provisions. Raven Paste boasted of producing a beautiful polish in one-third the time required by other products.

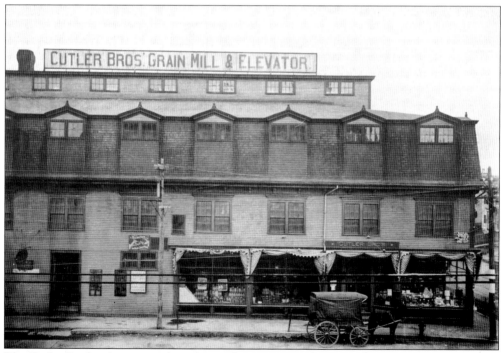

The Cutler Brothers' store stood on the southeast corner of Main and Water Streets. Lightning struck the three-story building on July 11, 1911, causing a devastating fire that destroyed Cutler Brothers, caused serious damage to the adjacent wooden Massachusetts Armory, and minor damage to the Evans Shoe Factory, Miller Piano Factory, and Town Hall.

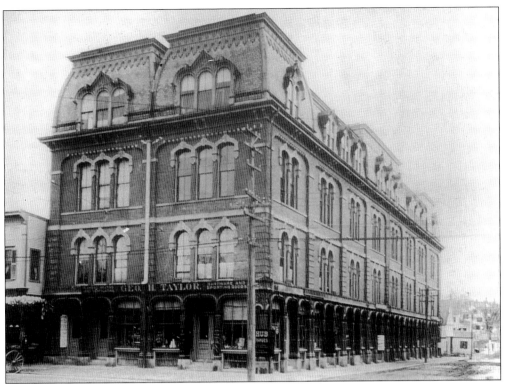

The Taylor Building, now named the Wakefield Building, was a commercial block on the corner of Main and Lincoln Streets constructed by Cyrus Wakefield. It is the last remaining building with an association to the town's benefactor. The structure has housed a variety of businesses over the years.

This trade-card advertisement for W. V. Taylor promotes his provisions.

The old Ira Wiley House, shown here, was moved to make room for a business block; the house stood on the west side of Main Street. Adjacent to the building stood an office for the local street railway system. At the extreme right was Britton's Shoe Store, later the Colonial Spa, and now the home of Cravings.

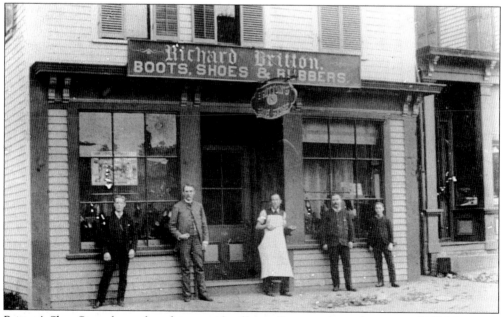

Britton's Shoe Store, located on the west side of Main Street, is shown here around 1880. Britton's dealt in boots, shoes, and slippers as well as hosiery, gloves, and suspenders. Its advertising circular claimed that "Customers will be ASTONISHED AT THE BARGAINS."

(OVER)

This advertisement for Britton's Shoes instructs shoppers that "Children's Shoes with the A.S.T.Co Beautiful Black Tip on them never Wear Out at the Toe, add to the Beauty of The Shoe, and double their value."

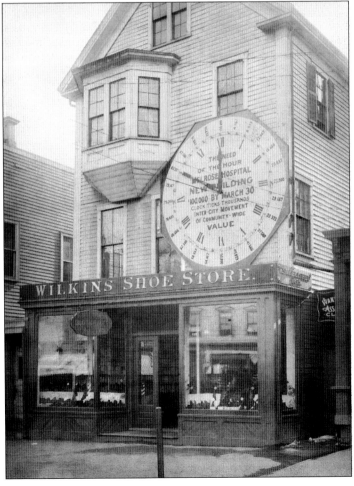

This 1912 photograph of Wilkins Shoe Store at 443 Main Street shows a dial documenting the progress of the Melrose Hospital Association building campaign. The shoe shop windows offer a tantalizing glimpse into the past. High-button shoes and ladies' dancing pumps were priced from 75¢ to $3.90. Posters inside the shop advertised Shinola shoe polish.

Bravo!
The Pet of the Nine.

FIRST INTRODUCED, 1833.

MERCHANT'S GARGLING OIL is the standard Liniment of the United States, and is good for Burns, Scalds, Rheumatism, Flesh Wounds, Sprains, Bruises, Lame Back, Hemorrhoids or Piles, Toothache, Sore Throat, Chilblains, Chapped Hands, and many other diseases incident to man and beast. Yellow Wrapper for animal, and white for human flesh.

Manufactured at Lockport, N. Y., by M. G. O. Co., and sold by all druggists.

OVER. **JOHN HODGE, Sec'y.**

J. M. Cate Clothing Store advertises "Gargling Oil" in this circular. Cate's shop was located on Main Street at the corner of Center Street.

A second ad for J. M. Cate's shows a clever attention-getting device. With a twist of the card, "our next president" could be either James A. Garfield or W. S. Hancock, thereby not offending anyone. The unfortunate Garfield won the presidency but was assassinated only four months after taking office in 1881.

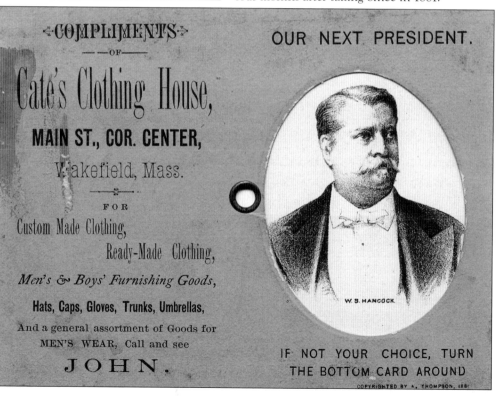

Bessey's Livery Stable, owned by William W. Bessey, occupied the corner of Main and Chestnut Streets and extended from Chestnut to Albion Street. This view dates from before 1923.

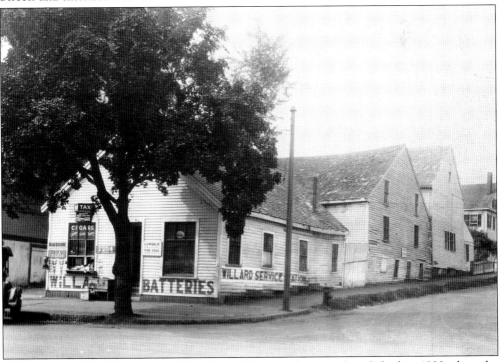

Willard Service Station occupied the front of Bessey's but was demolished in 1923 when the Wakefield Trust Company building was erected.

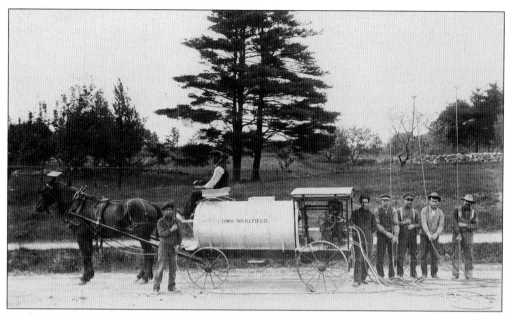

Machinist and carpenter Elwin Purrington created spray devices and wagons, seen here around 1900, for many local towns, including Wakefield. The father of longtime Wakefield Historical Society historian Clarence Purrington, Elwin was a native of Skowhegan, Maine, who made his home in Wakefield. His shop stood on Centre Street.

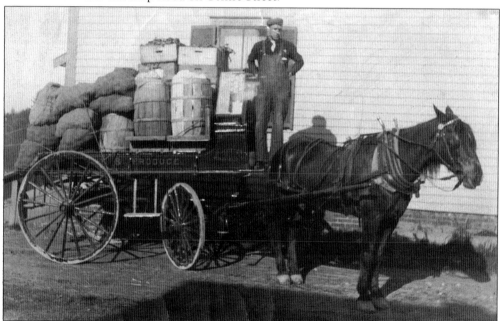

Bartholomew J. Cotter, an expressman in Wakefield, is standing in his wagon. To the left of his foot is imprinted "B. J. Cotter Wakefield." He took orders in Wakefield and picked up meat, produce, beer, and other items at different stops in Boston, including Quincy Market at Faneuil Hall, to deliver to his Wakefield customers. According to family lore, Cotter owned the first truck in Wakefield, an image of which he used in his ad in the *Wakefield Directory*. (Courtesy of Susan McDonough.)

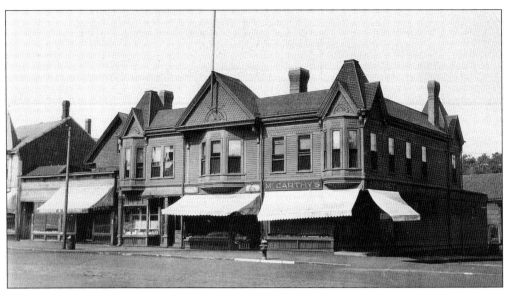

The Gould/Walton block at the corner of Main and Centre streets (present location of alano) was the home of the Quannapowitt Club, McCarthy's Market, John Jeffrey and Son's package store and several other prominent businesses. It was razed in 1938 to make room for a more modern structure.

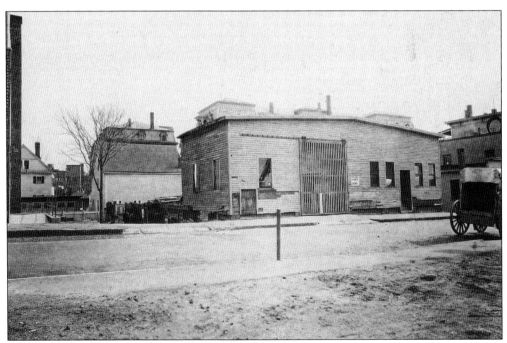

The historic Hathaway Stables located on Mechanic Street, now Princess Street, burned down in a devastating October 23, 1899, fire that destroyed 13 buildings. Rebuilt after the fire, the building fell into disrepair in 1920 when the roof collapsed under the weight of snow. Never fully repaired after that accident, the building was dilapidated in this 1925 view.

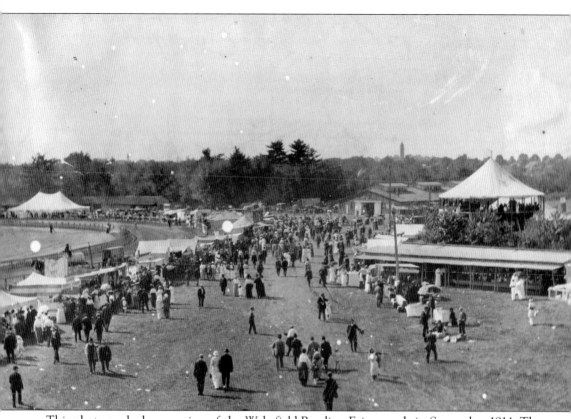

This photograph shows a view of the Wakefield-Reading Fairgrounds in September 1914. The fairgrounds flourished until the start of World War I. The outline of the track is still visible in the shape of Track Road in both Wakefield and Reading.

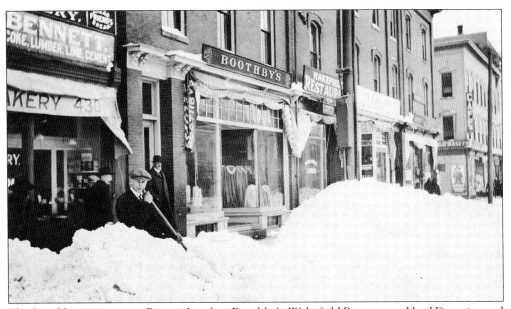

Blanketed by an ice storm, Bennet Lumber, Boothby's, Wakefield Restaurant, Hurd Druggist, and a café line the east side of Main Street.

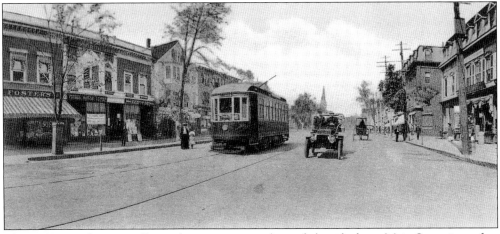

This 1907 view shows a trolley and a motorcar traveling side by side down Main Street in perfect comfort on the newly paved roadway.

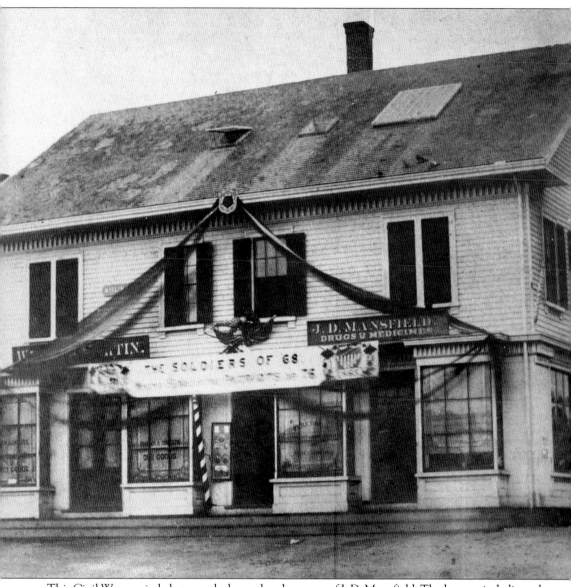

This Civil War–period photograph shows the pharmacy of J. D. Mansfield. The banner is dedicated to the "Soldiers of 68." The pharmacy was originally established on Main Street, across from Avon Street, by Dr. Joseph Mansfield and William Willis in 1847. Dr. Mansfield bought out Willis's share in 1855 and moved the business to the corner of Main and Albion Streets.

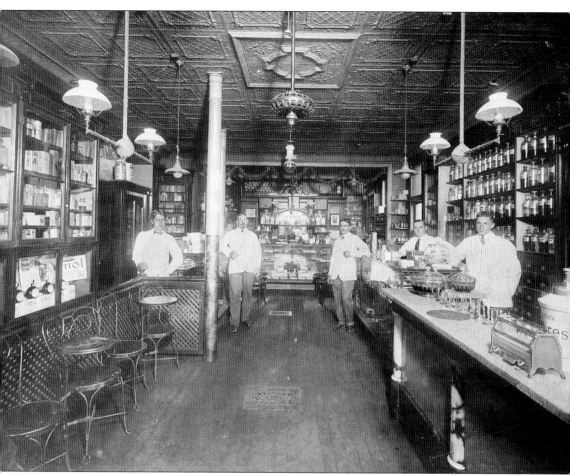

This is the interior of Bonney and Dutton's Old Corner Drug Store around 1910. Josiah Bonney became a partner in Dr. Mansfield's pharmacy in 1885 and eventually became sole owner, taking Riberot Dutton as a partner in 1906. From left to right in this photograph are Nat Eaton, Josiah Bonney, Riberot Dutton, an unidentified clerk, and Cliff Sawyer.

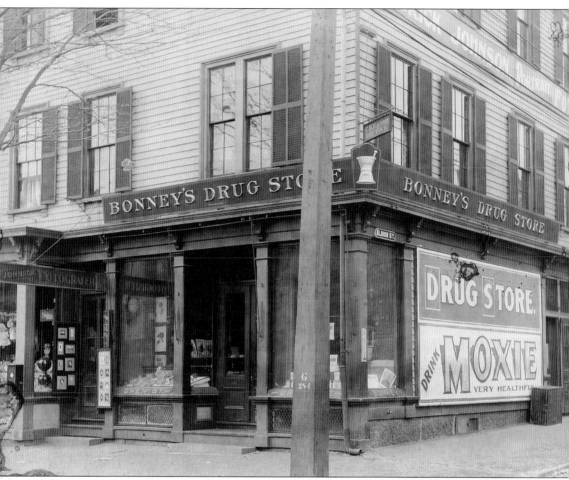

This exterior view of the Bonney and Dutton store at Main and Albion Streets offers a glimpse at a Coca-Cola thermometer on an exterior post as well as a large advertisement for Moxie and several merchandising placards and signs within the shop. Dentist C. H. Magoon could be found upstairs as well as a Mr. Johnson, "Portrait Fotographer."

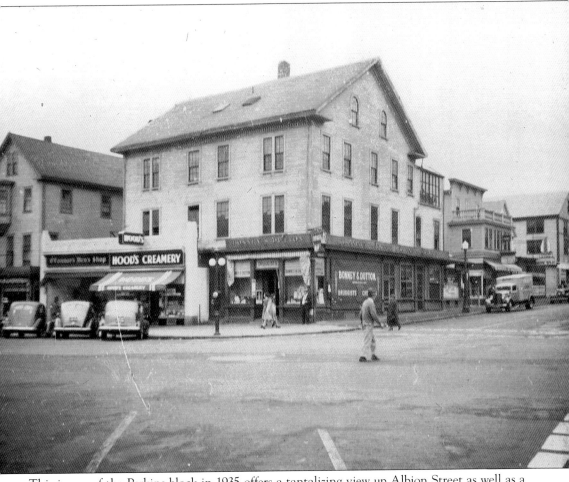

This image of the Perkins block in 1935 offers a tantalizing view up Albion Street as well as a good look at Main Street. The Perkins block was demolished in 1940 to be replaced by a new business block.

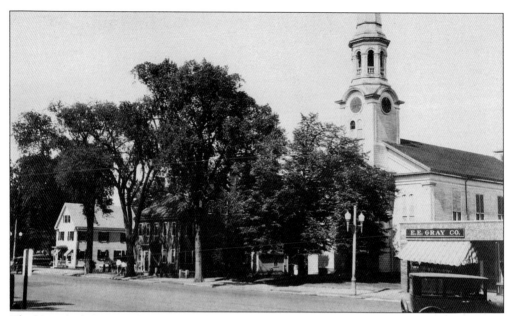

The Universalist-Unitarian Church on the east side of Main Street is flanked here by E. E. Gray Company. The church building, erected around 1839, is the oldest religious meeting place in town. The Universalist Society in Wakefield was founded in 1813.

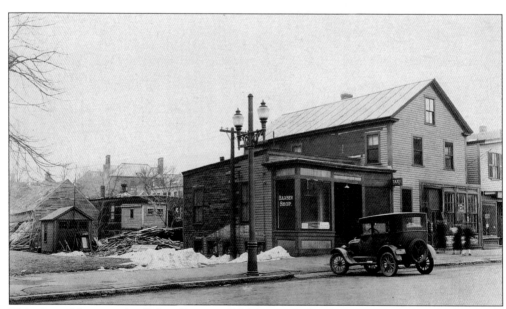

This view of the east side of Main Street in 1926 shows a barbershop, a taxi stand, and a distressing collapse behind the building.

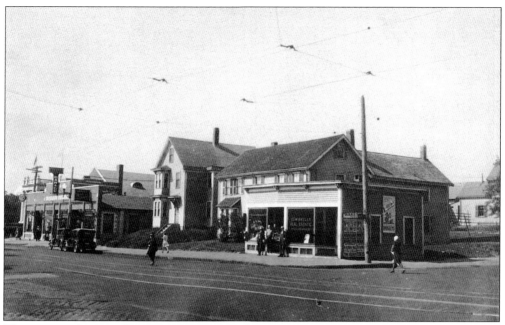

The area near Main and West Water Streets is shown here in 1929. Edwin Kelly's real estate office is on the corner, and circus posters adorn the side of the building.

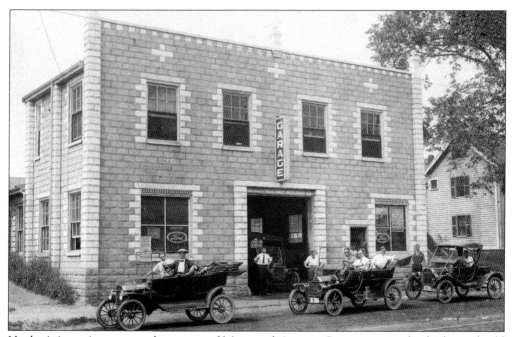

Hughes' Auto Agency, on the corner of Main and Armory Streets, serviced vehicles and sold automobiles to the public as well as to the police and fire departments. Joseph Hughes, reported to be the first man in town to own an automobile, built this garage in 1909 and owned it until 1920.

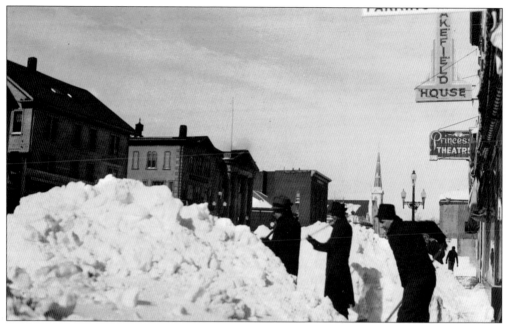

Wakefield was once the proud home to two movie theaters, which were both owned by the Princess Amusement Company, whose principal owner was Charles W. Hodgdon of Greenwood. The Princess Theatre, whose sign is visible here, was on Mechanic Street, later renamed Princess Street in the theater's honor. The Princess Theatre boasted 489 orchestra seats and 210 balcony seats. It was modernized in 1938 with an art deco facade and interior.

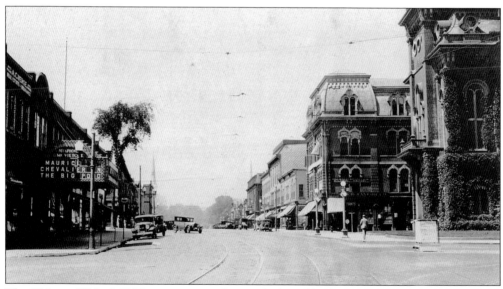

The 900-seat Wakefield Theatre occupied part of "the Old Theatre Block" at Main and West Water Streets. The block was originally constructed in 1915. A 1972 fire ravaged the building, but part of it was preserved to become the home of Farmland.

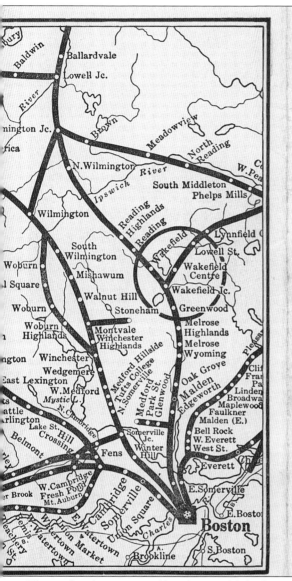

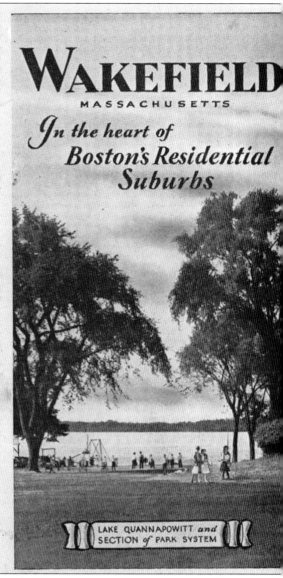

WAKEFIELD

MASSACHUSETTS

In the heart of
Boston's Residential
Suburbs

LAKE QUANNAPOWITT *and*
SECTION *of* PARK SYSTEM

This undated promotional brochure, published prior to the construction of Route 128, claims that a map is required to find Wakefield since it is not located on major highways.

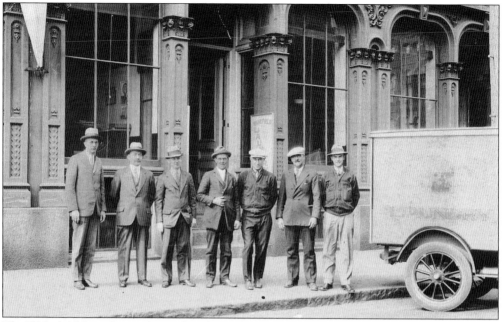

The Wakefield Laundry was located in the Taylor Building for many years. Owner Ernest Willard stands at left in this 1920s photograph.

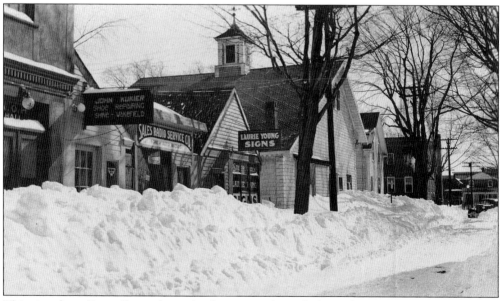

This view down Foster Street shows the shoe repair shop of John Kukier, a radio sales and service store, and the offices of sign maker and steeplejack Laurie Young.

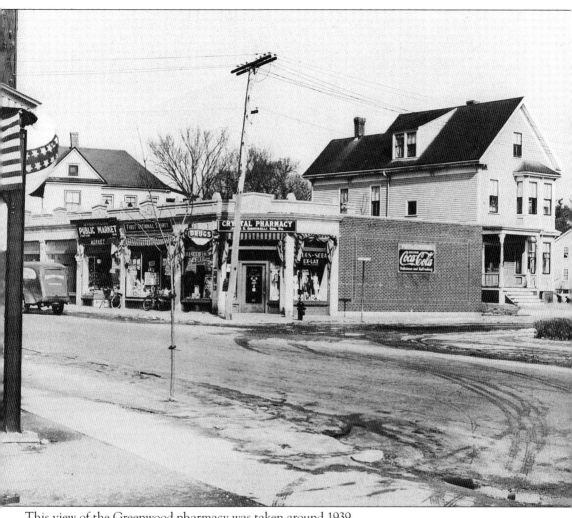

This view of the Greenwood pharmacy was taken around 1939.

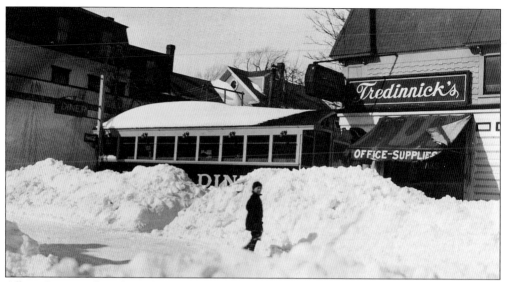

Albion Diner and Tredinnick's Office Supplies are shown in this snow scene.

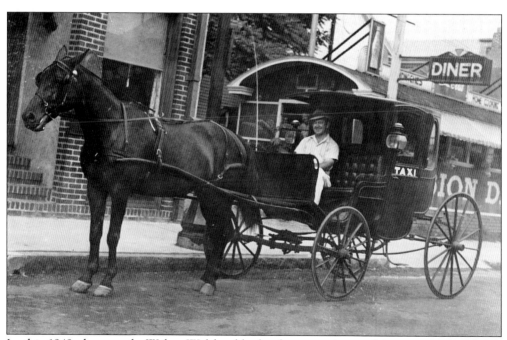

In this 1949 photograph, Walter Walsh adds the depot carriage to his equipment and acts as a chauffeur.

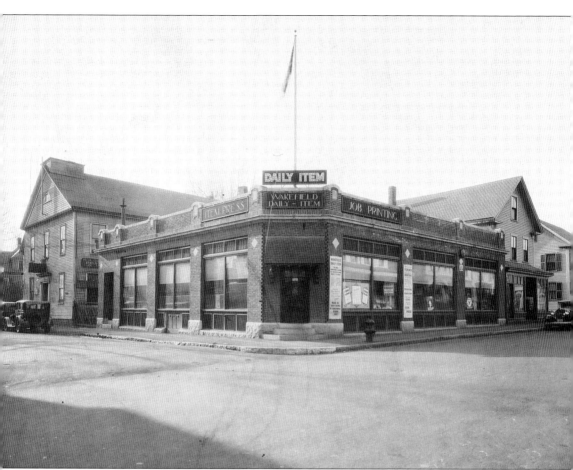

The *Wakefield Daily Item* newspaper office is shown here in November 1933. The *Item* was begun in 1894 by Fred Young and was acquired by the Dolbeare family in 1900. It has been owned and operated by the Dolbeare family since that time. The *Wakefield Daily Item* building, with an entrance on the corner of Albion and Foster Streets, was erected in 1912; an addition to the building was constructed in 1935.

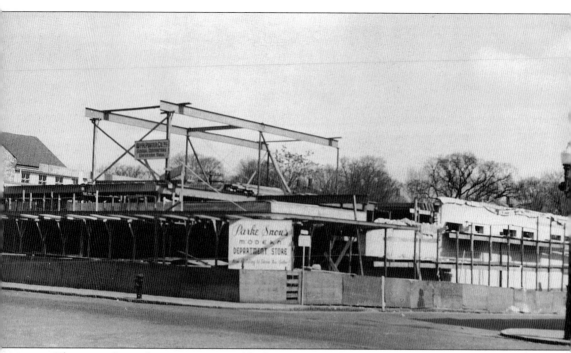

This view shows the construction of Parke Snow's Modern Department Store on the corner of Main and Centre Streets.

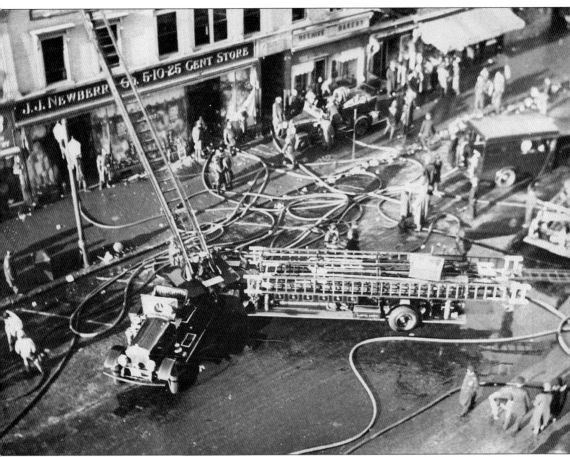

The fire at J. J. Newberry's 5-10-25 Cent Store ravaged the building on December 4, 1938. An estimated $50,000 worth of damage resulted from the fire, which was battled by firefighters from four towns. Other businesses occupying the Trader's block, as well as neighbors, were affected by the heavy smoke.

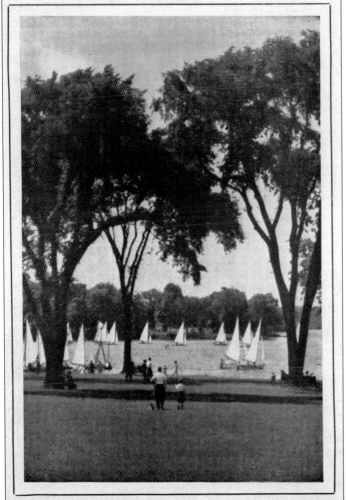

Wakefield

on-the-lakes

1950

WAKEFIELD CHAMBER OF COMMERCE

456 MAIN ST., WAKEFIELD, MASSACHUSETTS

This 1950 Wakefield Chamber of Commerce publication exhorted the public to visit the town and listed its industries—among them were aluminum spinning, automobile jacks, awnings, fibre mats, lead-lined pipes, model airplanes, and underwear.

Four

MADE IN WAKEFIELD

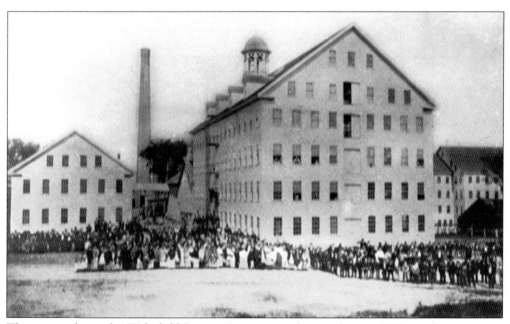

This image shows the Wakefield Rattan Company and its workers in 1875. At this time, two years after the death of Cyrus Wakefield, the business was still a thriving concern, as evidenced by the number of employees.

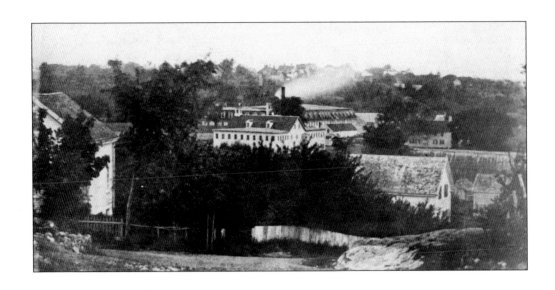

The growth of the rattan factory can be seen in the two photographs on this page. The *c.* 1870 image above features the original wooden buildings of the factory. By 1876, the factory encompassed 19 buildings with 10 acres of floor space and employed over 1,000 workers. A devastating fire in 1881 took down most of the buildings, yet the rattan factory continued to grow rapidly. The company's later buildings are shown below. By 1894, these included five four-story brick manufacturing buildings, a brick boiler house, a brick bleach house, a brick dye house, a brick office and pump house, and a brick paint shop and supply room. In addition, there were three frame storehouses, three iron and frame storehouses, two frame lumber sheds, two yarn houses, a frame cold-air dry house, a frame coal shed, and a frame barn and shed, totaling in all about 30 factory buildings located on 11 acres. In 1926, the factory employed 822 employees on 575,727 feet of floor space.

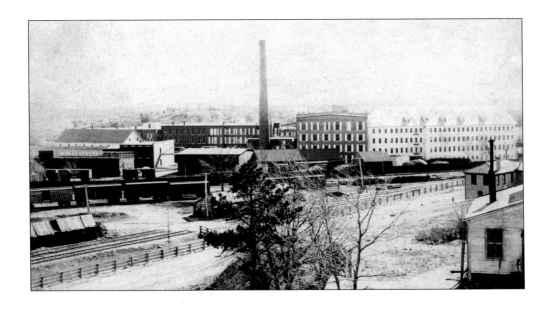

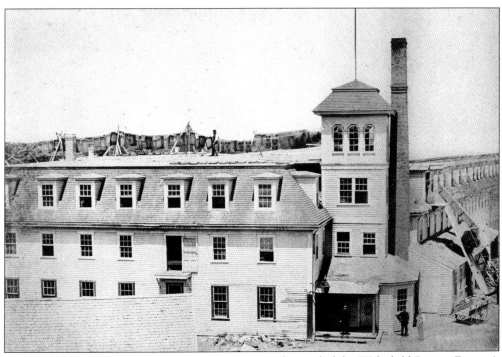

In this *c.* 1866 view, a worker hangs mats to dry on the roof of the Wakefield Rattan Factory's Stout Building, a cane and rattan shop. Although the primary product line manufactured by the company was furniture, Kurrachee Rugs were also an important product. One of the factory's buildings was dedicated to the manufacture of rugs. After the company's merger with Heywood Brothers of Gardner, Massachusetts, one of the specialty items produced was a circular mat, which was 44 feet in diameter and weighed 3,500 pounds, for the circus ring at the New York Hippodrome in New York City.

This advertisement lists four offices for the Wakefield Rattan Factory, including New York, Boston, Chicago, and San Francisco. Wicker and rattan furnishings became very popular during the Victorian era and retained their popularity through the 1920s.

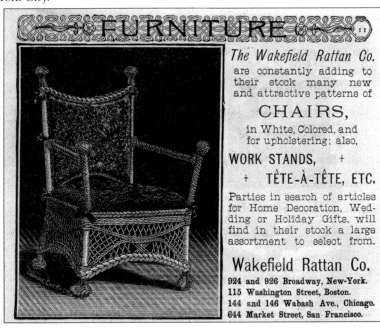

FURNITURE

The Wakefield Rattan Co. are constantly adding to their stock many new and attractive patterns of

CHAIRS,

in White, Colored, and for upholstering; also,

WORK STANDS, +

+ TÊTE-À-TÊTE, ETC.

Parties in search of articles for Home Decoration, Wedding or Holiday Gifts, will find in their stock a large assortment to select from.

Wakefield Rattan Co.

924 and 926 Broadway, New-York.
115 Washington Street, Boston.
144 and 146 Wabash Ave., Chicago.
644 Market Street, San Francisco.

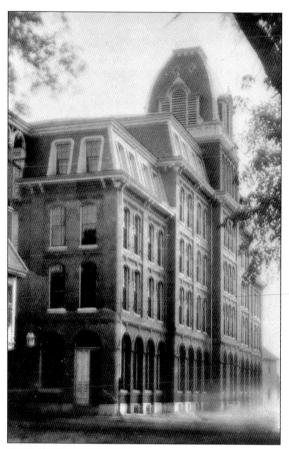

The brick machine shop of the rattan factory is seen in this view. After a devastating fire in 1881 took down most of the company's wooden buildings, they were quickly rebuilt, mostly with brick.

This rare view of West Chestnut Street shows the home and factory of Joshua Whittemore, manufacturer of the patented elastic crutch. This is one of the many innovative small industries that sprang up in 19th-century Wakefield; they ranged from the manufacture of awls and razor strops to shuttles and needles. The street where the Whittemore house stood was named Berlin Terrace until the advent of World War I, at which time it was renamed Whittemore Terrace in honor of its most prominent resident.

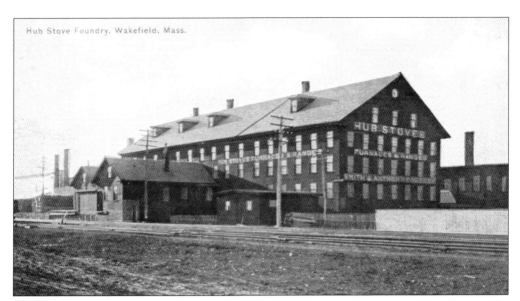

The Hub Stove Company was the descendant of the Boston and Maine Foundry, later renamed the Smith and Anthony Forge—prominent manufacturers of hollowware, bathtubs, and stoves. During the 1880s, production of hollowware was the third-largest industry in town. The factory was located on Foundry Street.

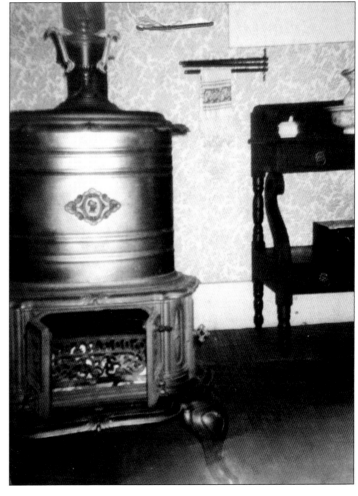

This is an example of a popular Hub stove made by the factory on Foundry Street in Wakefield.

99

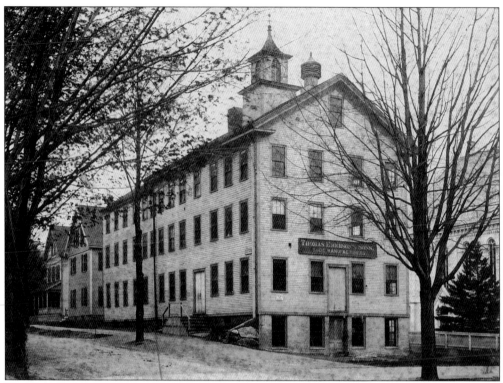

The Emerson Shoe Factory was one of the most prominent early businesses in Wakefield. The factory began at Lakeside and would move into Burrage Yale's old tin factory (pictured) in 1863. Before and after the Civil War, the Emersons sold a large percentage of their shoes in the South. During the war, they manufactured shoes for the Union Army.

Thomas Emerson, the founder of the Emerson firm, was also very active in the community. He served as a state representative and state senator, a member of the Board of Selectmen and School Committee, and the president of South Reading National Bank. The home of Thomas Emerson, located on the corner of Main and Wave Avenues, was an 18th-century house that was greatly remodeled before 1860. This lakeside landmark was torn down around 1920.

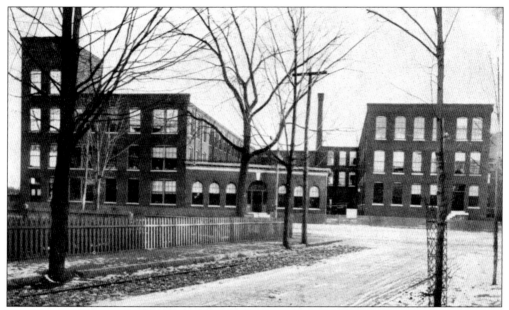

The Harvard Knitting Mill employed hundreds of people in Wakefield—both mill workers and women who worked at home crocheting lace onto the garments. The mill, which specialized in the manufacture of "Merode," a lightweight undergarment, was owned and operated by Elizabeth Eaton Boit and Charles Winship. Its brick buildings were constructed between 1897 and 1921.

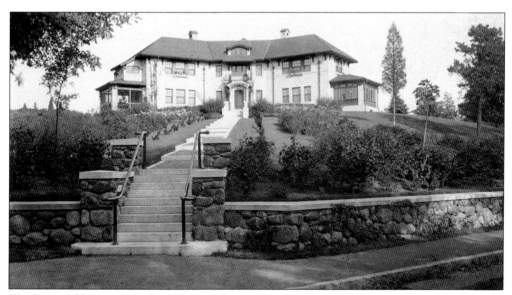

The beautiful home of Elizabeth Boit on the corner of Prospect and Chestnut Streets still stands. It was designed by architect Harland Perkins and built in 1911.

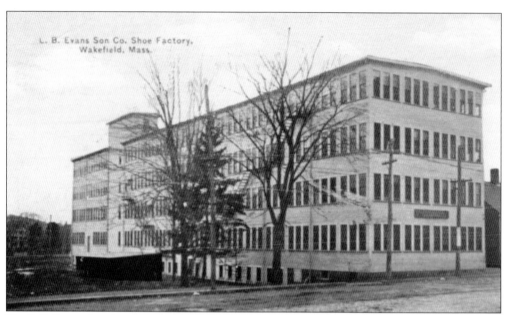

The L. B. Evans shoe factory is shown here. The Evans family had been prominent shoe manufacturers since the beginning of the 19th century, but it was Lucius Bolles Evans whose business was most successful. L. B. Evans built a new three-story factory on Water Street in 1894.

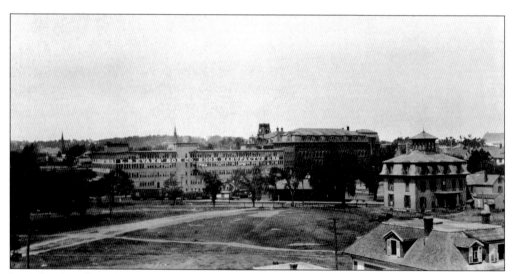

In its heyday, the L. B. Evans shoe and slipper factory employed hundreds of workers. Its sign is prominent in this photograph. The Evans factory had a total of 117,000 square feet of manufacturing and warehousing space in Wakefield in 1968. In 1979, the company was sold to the Anwalt Corporation of Fitchburg, which began phasing out its Wakefield facility. L. B. Evans left Wakefield completely by 1987.

Five

THE MARCH OF PROGRESS

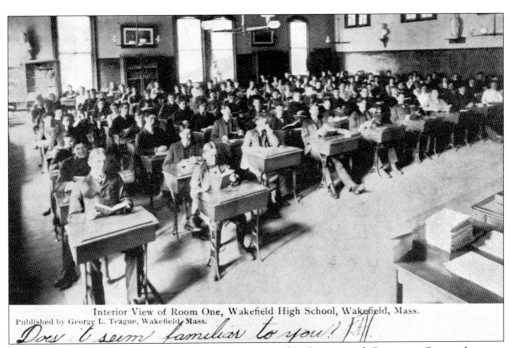

Interior View of Room One, Wakefield High School, Wakefield, Mass.
Published by George L. Teague, Wakefield, Mass.

Does it seem familiar to you? F.A.H.

As the town grew, the high school on the corner of Lafayette and Common Streets became overcrowded, as evidenced in this real-photo postcard. The move of the high school toward the Junction greatly impacted Main Street between Water Street and Broadway, which experienced the construction of a series of public buildings, changing its nature forever. This *c.* 1907 photograph shows an interior view of Room One at Wakefield High School.

The neighborhood of homes between present-day Armory and Water Streets is shown here in the late 19th century. Cyrus Wakefield Sr. owned the first building to the left, which was the home of his coachman and gardener, a Mr. Haverty.

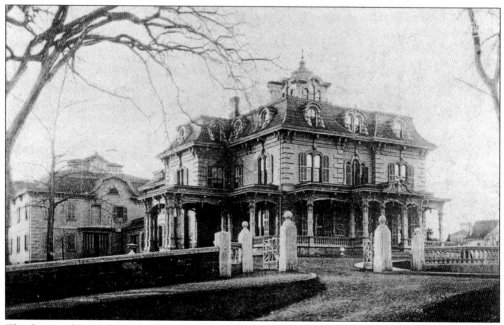

This home of Cyrus Wakefield, foremost citizen of the town that would take his name, is seen here in about 1880, after his death in 1873. Constructed in 1863, the estate had a barn of comparable size, along with a summerhouse, orchards, and greenhouses. The residence was demolished to make room for a new high school, which opened in 1923.

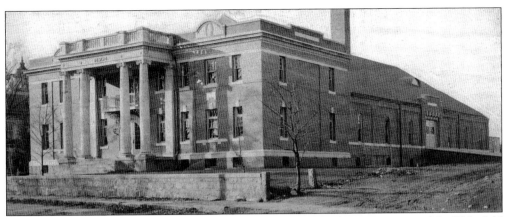

The row of homes shown on the previous page was demolished for the construction of the Wakefield Armory Building, pictured in 1916. The armory replaced a previous wooden building, constructed in 1911, which burned down in the conflagration that devoured the Cutler Building. The brick armory, now known as the Americal Civic Center, was built in 1913.

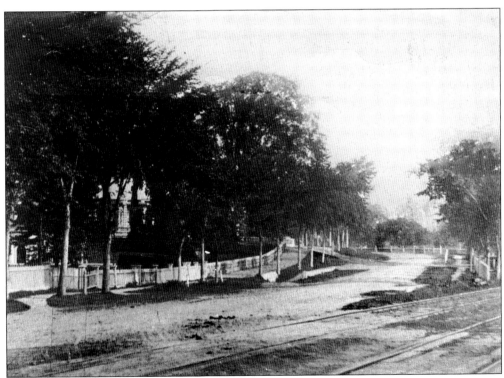

The former bucolic nature of Main Street, near Bennett Street, is evident in this view. The Wakefield mansion was located to the left of this scene, just out of view.

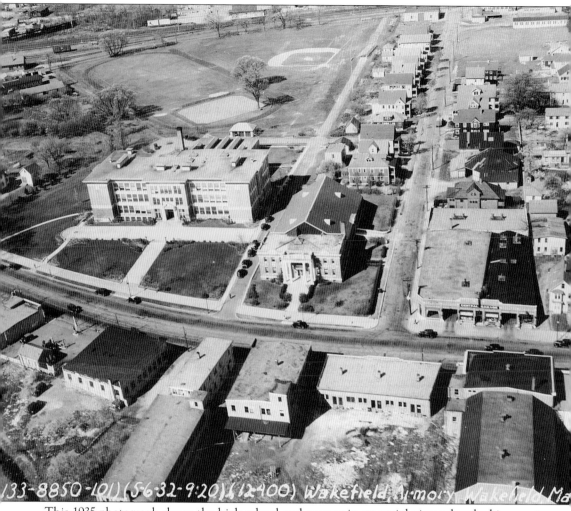

133-8850-101)(5-6-32-9-20)(12400) Wakefield Armory Wakefield Ma

This 1935 photograph shows the high school and armory in an aerial view taken looking west from the vantage point atop the Evans Company factory on Water Street.

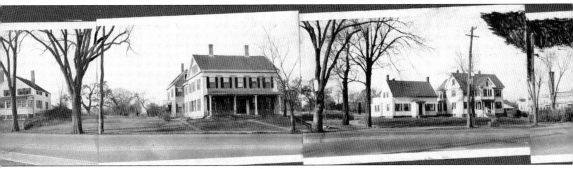

This view shows the collection of houses that were taken down in 1954 to make room for an extension to the high school building. From left to right, the houses were owned by A. Mildred Hawkes, Marjorie Cook, John F. Marshall, and James E. Murphy. The Cook house was moved to the corner of Park and Prospect Street, where it stands today. All the other homes were razed.

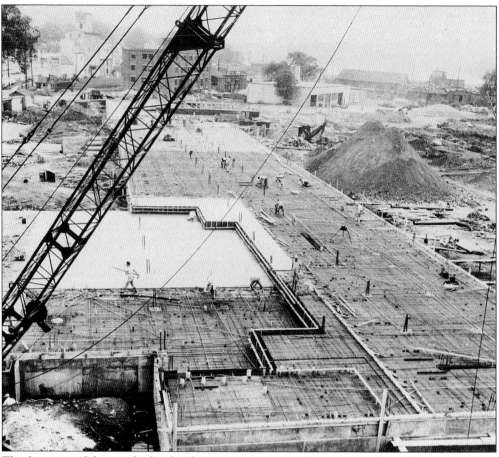

The footprint of the new high school extension is seen in this view, which looks south.

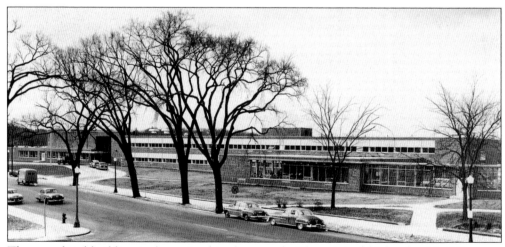

The completed building is shown in this photograph. The original high school building was renamed the Willard J. Atwell Junior High School and was used as such until the new junior high opened on Farm Street in 1960.

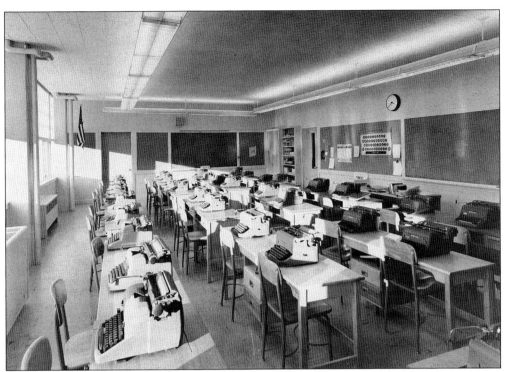

The new facility was outfitted with the most modern of equipment, as this classroom photograph shows.

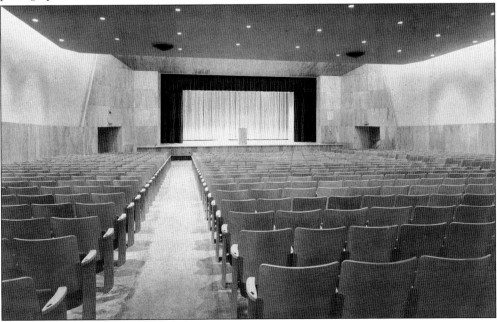

The auditorium of the new building was considered quite capacious and comfortable at the time. It boasted 904 seats, at a cost of $17.50 per seat, with letters and numbers attached. It had 156 aisle lights. A motion picture projector with sound was also purchased for use in the auditorium at a cost of $1,500.

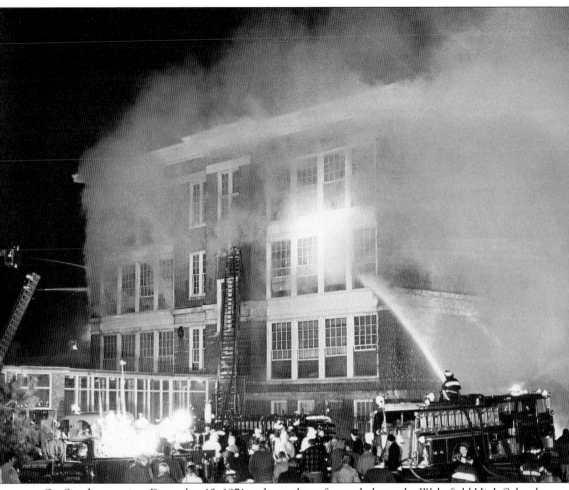

On Sunday evening, December 12, 1971, a three-alarm fire took down the Wakefield High School Annex (the old high school building). A total of 18 fire engines, five aerial ladders, one tower ladder, one snorkel, two rescues, eight lighting plants, and one C. D. engine, including all of Wakefield's apparatus, responded to the fire. The insurance loss paid was $1,370,111.30.

Six

WAKEFIELD CELEBRATES

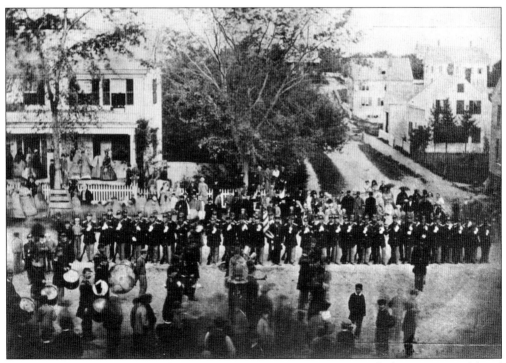

From salutes to our troops and patriotic commemorations to national observances and local anniversaries, the town of Wakefield embraces the celebration of community. In this rare photograph, the Richardson Light Guard parades prior to leaving for service in the Civil War. The scene shows Main Street where it intersects with Mechanic Street (now called Princess Street). Ladies on the porch have gathered to salute the troops.

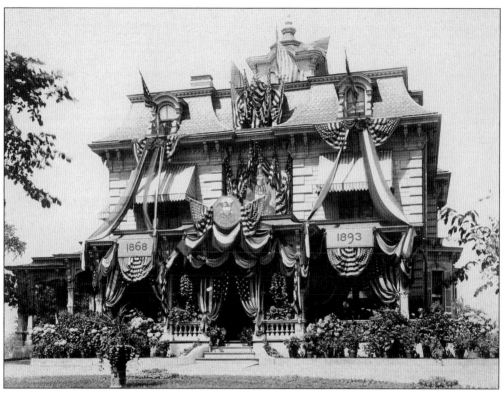

One of the town's biggest celebrations was the commemoration of the 250th anniversary in 1894. The town was lavishly decorated for the event, as evidenced by this photograph of the Cyrus Wakefield mansion, located where the parking lot of the Galvin Middle School now stands.

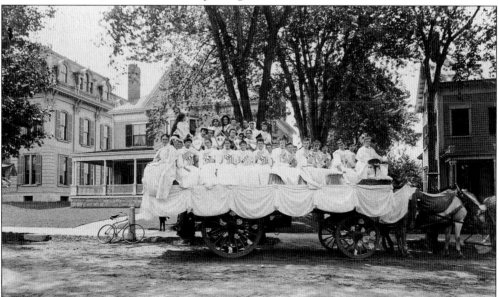

The Wakefield High School float for the 1894 parade featured girls portraying the states, the four seasons, and Columbia. One of the participants later complained that the driver was heedless of the low branches along the route, causing the destruction of many hairstyles.

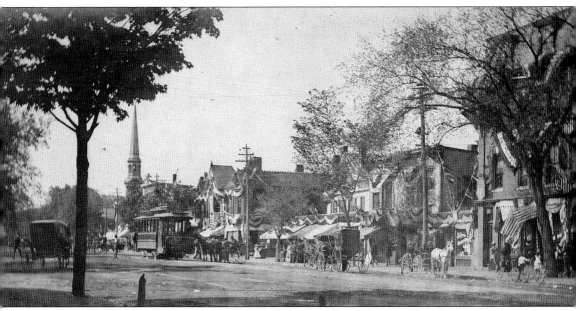

The Wakefield Historical Society has recently discovered a series of glass-slide negatives, casting a new light on the town during the 250th anniversary. In this photograph, preparations are ongoing, with trolleys arriving, numerous wagons in view, and many bicycles parked near the curb.

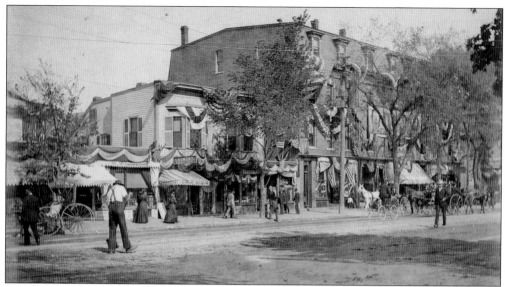

Main Street is unpaved in this view of preparations for the 250th anniversary celebration. Here a worker strews gravel on the street in front of shop windows advertising "Ice Cold Soda" and "Hot Coffee."

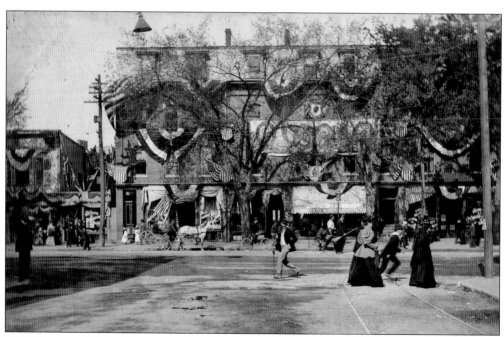

There is unparalleled movement in this 1894 photograph as people rush off to celebration activities. The buildings are draped with bunting, and children in white await the festivities.

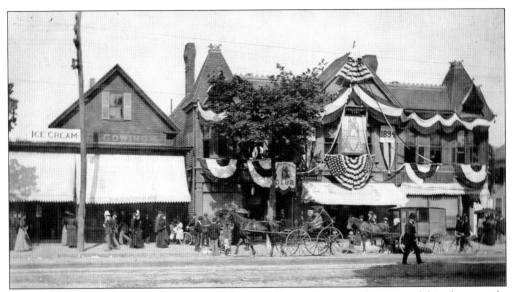

The Quannapowitt Club on the corner of Main and Centre Streets is the scene of this photograph, which also shows Gowing's Provisions and an ice cream shop. The front of the Quannapowitt Club building bears the club's emblem along with a portrait of Columbia.

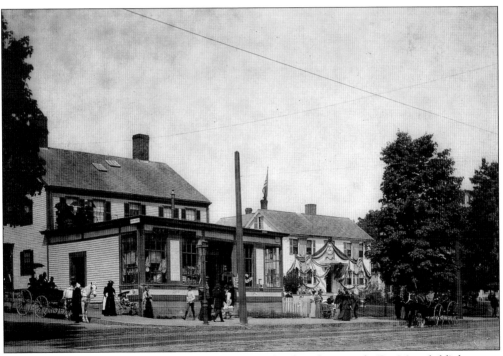

The corner of Main and Avon Streets is the scene for this photograph. Dr. Mansfield's house is visible in the background, and in the foreground is a variety store. Both structures were replaced by the Beebe Memorial Library.

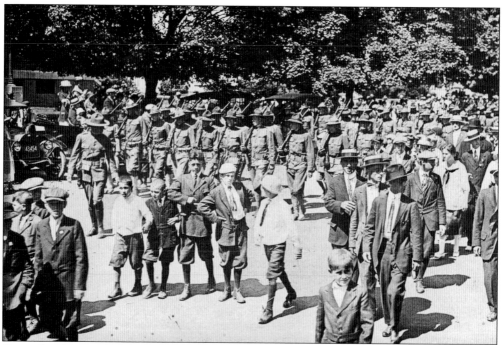

Soon after the United States entered World War I, Wakefield's recruits were called to duty at Fort Revere in Hull and thereafter to Fort Devens. They returned for a brief trip home prior to being sent to France. Well-wishers packed the streets from the Common to the armory.

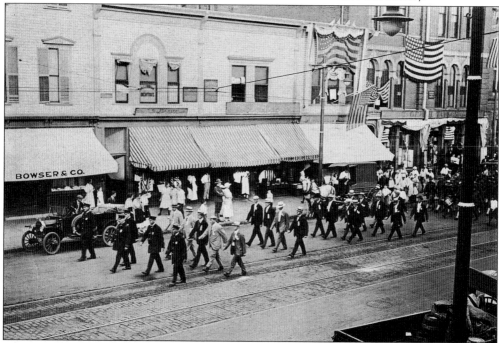

A parade formed to give the troops a proper salute prior to their deployment in France. Here police officers and public officials led the way to the Common, passing the Taylor Building and Bowser and Company.

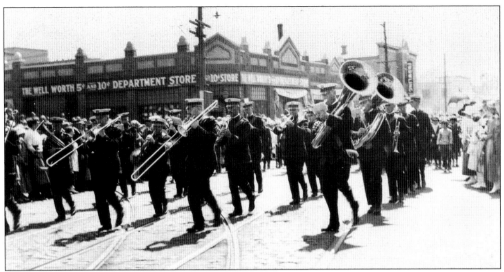

A military band and an abundance of patriotic fervor accompanied the send-off of the town's troops to their nation's service in World War I. Even after the troops' deployment, uniformed men were often seen in Wakefield's streets since nearby Camp Plunkett, located at the present Camp Curtis Guild, served as a naval rifle range.

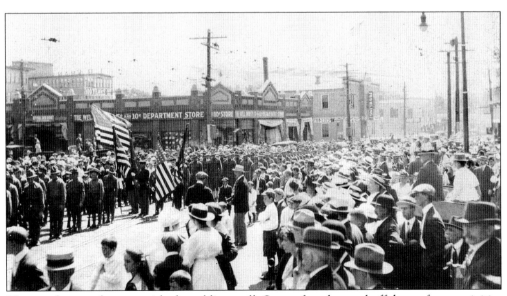

Thousands turned out to wish the soldiers well. Soon after the send-off, home-front activities abounded as residents joined together to grow extra crops, raise additional livestock, and put together care packages for servicemen.

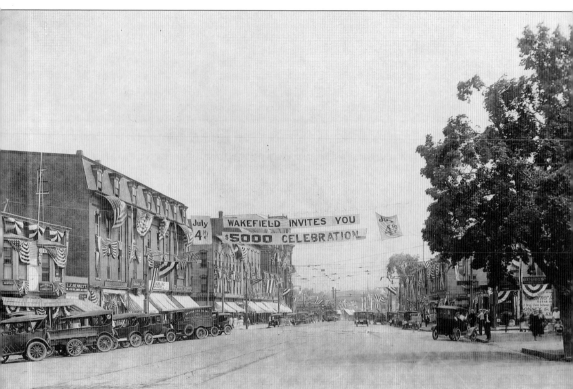

In 1922, the Wakefield Chamber of Commerce, whose membership then numbered 500, decided to put Wakefield on the map with a Fourth of July of unparalleled distinction. Led by then-president Lauren McMaster, the chamber committee labored long to put together the biggest parade since the 250th anniversary. This banner over Main Street announces the fund-raising goal of $5,000. Sadly, organizers fell $1,000 short, despite a great deal of optimistic preparation and enthusiastic participation by businesses and organizations. On top of everything else, weather did not cooperate, and the $1,000 fireworks display had to be postponed. Two years later, the *Wakefield Daily Item* alluded to the event as having been run by the "now defunct" Wakefield Chamber of Commerce. The Wakefield Chamber was reborn in 1934.

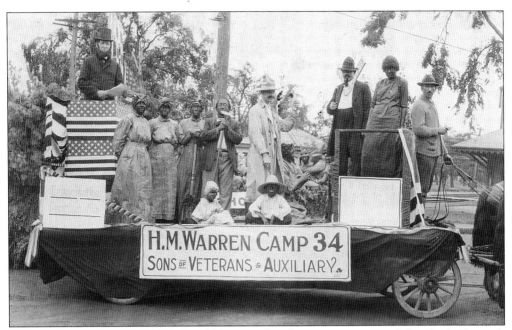

The H. M. Warren Camp 34 Sons of Veterans Auxiliary commemorated the Civil War with this float showing Abraham Lincoln freeing the slaves. Parade organizers were mindful of the crowd's comfort and made sure public buildings were open for restroom facilities. The day before the celebration, the committee was still requesting donations: "Don't let one-tenth of Wakefield's population foot the bill!"

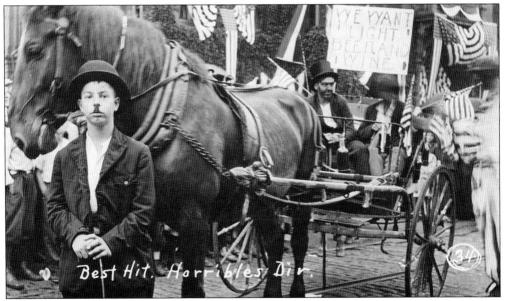

The Best Hit in the Horribles Division featured this young Charlie Chaplin impersonator with his crew of "horribles" and a sign demanding "We want 'Light' Beer and Wine." The Horribles Division enjoyed great popularity with the young since it was the only parade category offering cash prizes. First prize, won by this float, claimed $12. Four other prizes were offered, with a total of $52 going to cash awards for the Horribles participants.

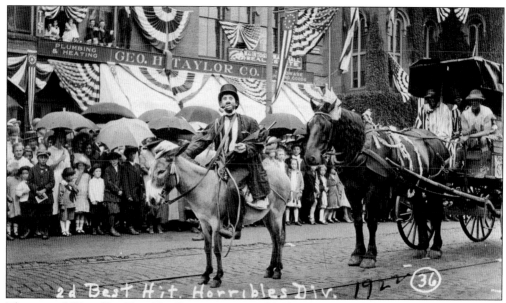

The second "Best Hit, Horribles Division" stopped before the Taylor Building to give the crowd a good look at the display. The rain did not put a damper on the festivities, and many of the assembled onlookers had prudently brought along umbrellas.

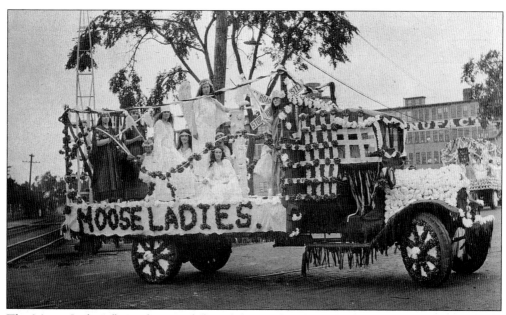

The Moose Ladies' flower-festooned float did not take a prize but won much admiration from the crowd. The float was photographed as part of a gallant effort by Bourdon Studios and the *Wakefield Daily Item* to document the festivities. The two businesses had photographs ready in record time so that participants could have a souvenir of the noteworthy event.

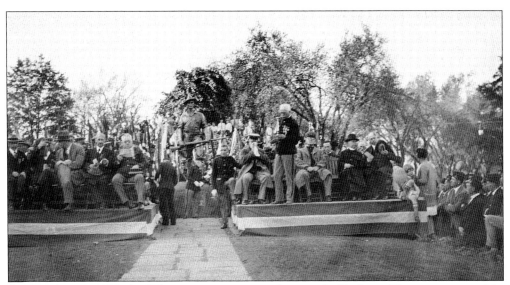

On October 12, 1926, the *Hiker* statue was put in place on the Rockery. The statue, created by artist Theo Kitson, was dedicated in honor of the Wakefield citizens who took part in foreign action in the Spanish-American War. The ceremony took place on the 75th anniversary of the Richardson Light Guard.

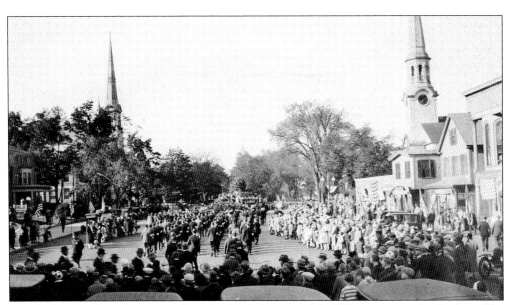

Hundreds of local residents turned out for the dedication of the *Hiker* statue on the Rockery. The Rockery, originally nicknamed the "Sylvan Grotto and Fountain Park," was put in place in 1884 and has become a well-loved monument in Wakefield.

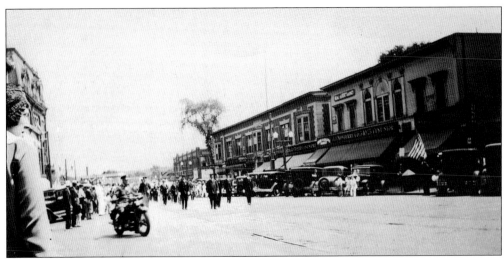

During the Memorial Day parade in 1932, Joe Preston is shown on a motorcycle, with police chief John Gates leading the parade.

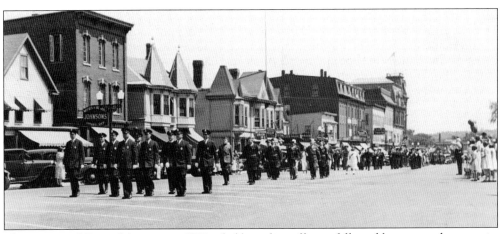

This Memorial Day celebration in 1937 is led by police officers, followed by men and women in the uniforms of the armed forces. The Memorial Day parade in Wakefield is a joint effort between the town and military organizations. From 1936 to 1990, the Independence Day parade was run by the West Side Social Club (WSSC) as part of its daylong festivities. In 1991, the Wakefield Independence Day Committee assumed responsibility for the parade. The two groups annually contribute to a memorable Fourth of July experience for Wakefield residents and thousands from neighboring communities.

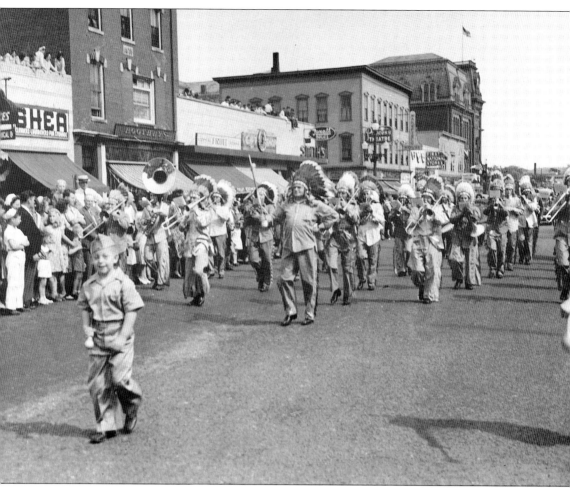

Wartime brought out the best in the community, as exhibited in a spirited parade entry by the Redmen's Band, including Leonard Bayrd. A talented musician and descendent of Narragansett Indians, Bayrd led the Redmen's Band for many years. At his Bayrd's Trading Post at the head of Lake Quannapowitt, he fabricated headdresses that were worn by cheerleaders for the Wakefield High School Warriors' games.

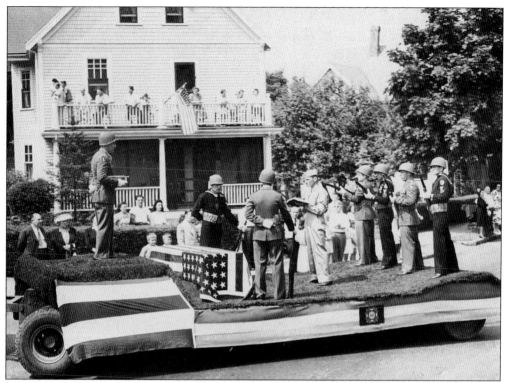

The 1948 Independence Day parade showed an emphasis on returning veterans as well as those who did not return. This photograph shows a float paying tribute to those who had perished while in the service of their country during World War II.

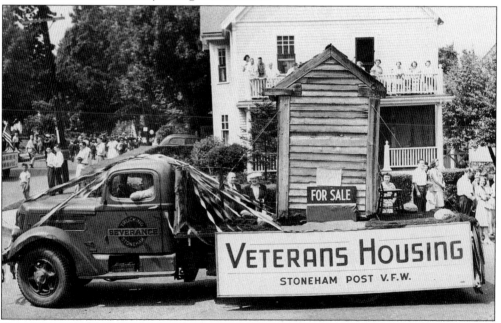

Over the years, Wakefield's parade, which is regionally renowned, has drawn participants from other communities as well. Here Stoneham Post VFW gives a comic view of "Veterans Housing."

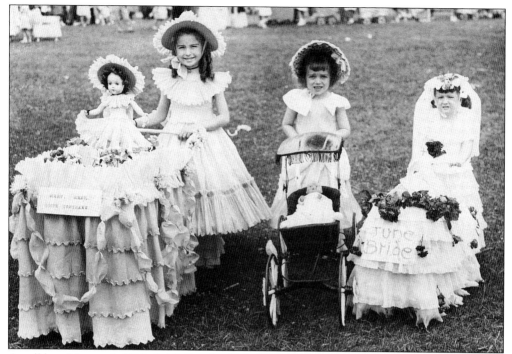

A well-loved feature in Wakefield's Fourth of July festivities is a full day of activities for children and families sponsored by the West Side Social Club. In 1950, winners of the doll carriage parade include "Mary, Mary, Quite Contrary" and a "June Bride." The WSSC's full day of events traditionally begins with a fishing derby, continues with footraces and other family-oriented competitions, and ends with a concert on the Common and fireworks over Lake Quannapowitt.

The Independence Day parade has shown many fine floats through the years, including this 1950 submission by the Wakefield Elks. Featured are Betsy Ross, a colonial flag, and the motto "The Flag—Foundation of Elkdom."

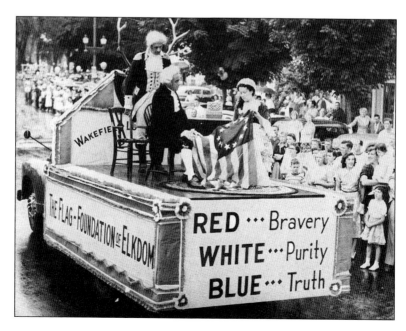

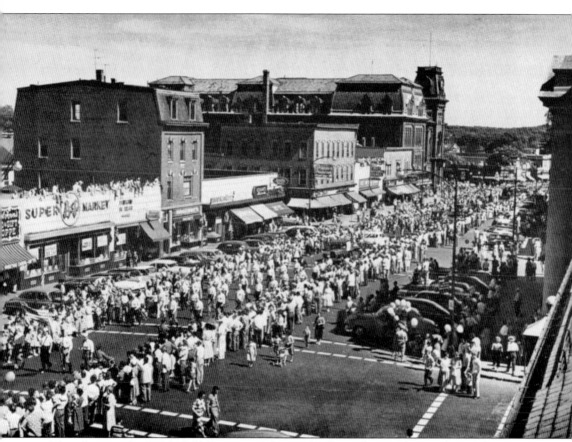

This photograph of Wakefield Square on July 4, 1953, shows the popular parade and also provides a view of the evolution of Main Street. At far right are the Cyrus Wakefield Town Hall and the Taylor Building (with mansard roof intact). Farther down are the First National Store, the Princess Theatre sign, Crystal Fruit, the A&P Supermarket, and the Carol Ann Card and Gift Shoppe, among other long-gone businesses.

Wakefield 350, the organization responsible for coordinating the 1994 celebration, began with representatives from the Board of Selectmen, the School Committee, the Wakefield Chamber of Commerce, the Council of Clubs, the Wakefield Historical Society, the Wakefield Historical Commission, and anyone else who cared to participate! The result was an enthusiastic and memorable celebration.

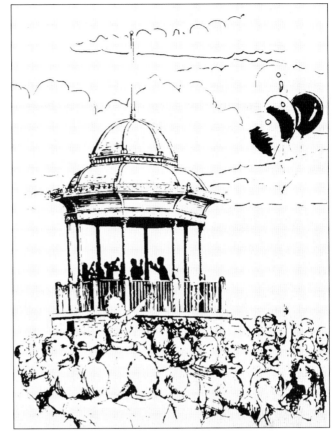

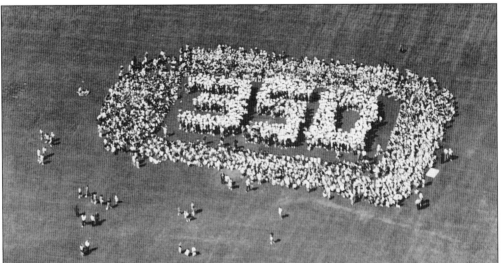

The town's 350th anniversary celebration featured the publication of a complete history of Wakefield and a fortnight of events, including a parade of children from Galvin Middle School to the Common, where a time capsule was buried. Before departing from the school, the children formed a 350, photographed by a local pilot. Two new events—Midsummer Night and the Homecoming—were held annually until 2007.

www.arcadiapublishing.com

Discover books about the town where you grew up, the cities where your friends and families live, the town where your parents met, or even that retirement spot you've been dreaming about. Our Web site provides history lovers with exclusive deals, advanced notification about new titles, e-mail alerts of author events, and much more.

MADE IN THE USA

Arcadia Publishing, the leading local history publisher in the United States, is committed to making history accessible and meaningful through publishing books that celebrate and preserve the heritage of America's people and places. Consistent with our mission to preserve history on a local level, this book was printed in South Carolina on American-made paper and manufactured entirely in the United States.

This book carries the accredited Forest Stewardship Council (FSC) label and is printed on 100 percent FSC-certified paper. Products carrying the FSC label are independently certified to assure consumers that they come from forests that are managed to meet the social, economic, and ecological needs of present and future generations.

FSC
Mixed Sources
Product group from well-managed
forests and other controlled sources

Cert no. SW-COC-001530
www.fsc.org
© 1996 Forest Stewardship Council

Find Your Place in History.